D1224624

Conscious Ink

THE HIDDEN MEANING OF TATTOOS

Mystical, Magical, and
Transformative Art You Dare to Wear

LISA BARRETTA

A division of
The Career Press, Inc.
Wayne, N.J.

CONSCIOUS INK: THE HIDDEN MEANING OF TATTOOS
Typeset by Diana Ghazzawi
Cover design by Howie Severson
Cover photo by Viachaslau Rutkouski/dreamstime
Printed in the U.S.A.

To order this title, please call toll-free 1-800-CAREER-1 (NJ and Canada: 201-848-0310) to order using VISA or MasterCard, or for further information on books from Career Press.

The Career Press, Inc.
12 Parish Drive
Wayne, NJ 07470
www.careerpress.com

Library of Congress Cataloging-in-Publication Data

CIP Data Available Upon Request.

ACKNOWLEDGMENTS

To Alison, my daughter, my editor, my second set of eyes, who definitely earned her seat at Starbucks while looking over my work.

To B.J., my older son, for all of his help with the photographs and his expertise in making my book trailer.

To Nick, my younger son, who helped me format the manuscript. Thank you, or as they say in Japanese, *arigatou*. (I italicized foreign words like you told me to do.)

To my parents on the other side of the veil, Mom (who thought my tattoo was washable ink) and Dad (who didn't know I had a tattoo). See? My getting a tattoo wasn't so crazy after all.

Big thanks to my friends Mary and Sue, Mary for recommending some inspiring tattooists to interview and for sending positive Reiki energy my way, and Sue for the pretzels and donuts. (Comfort food and a sugar high. What more could a writer ask for?)

Thank you to Daemon and Raven Rowanchilde, Josh Adair, Victoria Wikler, Dave and Elizabeth Cutlip, and Alex March, my go-to tattooists who provided me with incredible insight about the spiritual, mystical, sacred art of tattoos.

Thank you to all of the people who contributed to *Conscious Ink* by sharing their stories and pictures of their tattoos. May your ink always be an open portal to enlightenment.

All that we see or seem is but a dream within a dream.
—Edgar Allan Poe

Contents

Introduction...9

Chapter 1
More Than Skin Deep...17

Chapter 2
Modification of the Body and Spirit........................35

Chapter 3
Tattoos Through the Lens of Consciousness.....................55

Chapter 4
Mysterious Portals to Otherworlds.........................77

Chapter 5
Archetypes: Who Do You Dare to Wear?.............................97

Chapter 6
Symbols and the Language of the Soul.............................125

Chapter 7
Scars That Wound, Scars That Heal........................193

Bibliography...211

Index...213

About the Author...223

INTRODUCTION

There is no denying that tattoos have a certain type of energy. They not only hint at your daring side, but also open a portal into the dimensions of your soul.

Thousands of years ago, ancient indigenous cultures recognized a deep connection to the cosmos, nature, and the realm of spirit as evidenced in their art, symbols, metaphorical myths, and use of tattoos. These venerable cultures weren't superstitious; they were enlightened. Their close relationship with the spirit world wasn't muted by religious dogma or overshadowed by technology. It was a true, pure, authentic connection that very few cultures maintain today. They knew there was a mystical connection in art and symbols, and an even more profound magic in creating and adorning themselves with tattoos. Images that were put on the skin represented an embodiment that linked directly to consciousness. Tattoos told stories, encouraged healing, empowered the wearer, and tapped into the hidden realms of the spirit. Tattoos were, and still are, powerful symbols that speak the cryptic language of the soul.

Consciously tattooing can be a vehicle for self-empowerment. When you decide to get a tattoo, you are taking part in a potent blood ritual that opens your inner pathways to self-awareness. Getting a tattoo goes well beyond just capturing an image on your body; it also stirs up the emotional cellular memory that lies beneath your skin. You are crossing a threshold and making a commitment to an inked-on symbol that you not only wear outwardly, but also embody.

Now, you might be thinking it's just a little symbol or a cool image, but believe me: your tattoo holds volumes of inner information. The symbols in themselves represent an archetype—or possibly your shadow—that is pulled forth through the decorative tattoo portals you place on your body. It can mean something deep inside of you wants to be outwardly expressed. Alternatively, your consciousness is calling for something to be added so you can embody the energy and power represented by the image you decide to ink.

Tattoos are usually synchronized to events in your life that come from an emotional connection to an experience, a dream, an inner urge, or a certain something or someone. When you ink an image onto your body, you are embodying the vibration of the symbol's meaning, the color, the transference of energy between you and the tattooist, and even the qualities of the ink. Combined, they're a personal form of alchemy. Tattooing beyond the sake of vanity can initiate your own shamanic journey into your consciousness, to reveal what's hidden in the matrix of the body, mind, and spirit.

You don't have to be tattooed with sacred geometric symbols or tribal motifs in order to tap into the mysterious meaning of tattoos. Even your silly or dark tattoos have very profound personal meanings and hold within them a type of magic that actively interacts with your own energy field and the areas on your body that store emotional memory. For example, a tattoo on your neck relates to where your thoughts and emotions come together. What tattoo image is conveying that message for you? Tattoos on your arms and hands tap into the area on your body that holds emotions in relation to your external world and show what you embrace. Who, or what, are you holding on to? Or, what do you want to let go? Tattoos may even wake up some past-life memory that needs healing or possibly reveal a profound message for you in this lifetime.

Yes, tattoos go beyond skin deep. Put a tattoo on your body, and it becomes a sentient image and a portal into your consciousness.

In this book, you will see some very compelling examples of how tattoos precipitated a healing, opened the doors to recognizing profound knowledge, and symbolically represented and activated the embodiment of an intended desire. Ah-ha—that brings me to intention. *Conscious Ink* is about tattooing with intention. An intention behind getting a tattoo gives you more focus and control over the hidden magic in your ink. Once you realize tattoos create an energy exchange with the physical and subtle bodies, you will most likely disengage from the standard opinion that classifies tattoos as merely

body art. There is a very cool, supernatural side to tattoos, and they are an unequivocal vehicle for transformation and awareness.

I spoke with several people who have tattoos, and some of their experiences go beyond the norm. Some saw their tattoos as a fleshy vision board to embrace the laws of attraction, and others felt they manifested a stronger force that helped them heal an inner trauma. Many of those I talked to were inspired to get a tattoo because of an intense dream, and there were even some who became conscious of a past-life incarnation as a result of their ink. What your tattoo reveals inwardly is often more profound than the expression of the outer image. You never know what your tattoo will invigorate inside of you that relates to the many journeys of your immortal soul.

Conscious Ink isn't a tattoo picture book, nor is it a tattoo history book. It is all about looking at tattoos through the lens of consciousness, the term we loosely call "spiritual." After all, tattooing is a sacred art, rich in symbolism, ritual, and mysticism. You will come to understand the importance of intention, the vibration of colors, and how body placement all combine with your subtle body energy field to create a permanent body talisman for better or worse. They are spiritual birthmarks, or soul prints, markers along your path to wholeness.

Tattoos offer the opportunity to awaken the creative visionary within your consciousness. The images and symbols you can tattoo are endless. (I could have written a whole book just on that topic alone!) Be creative and feel free to make the symbol your own by using the colors and style that speak your voice and to the musings from your soul. There are many ways to envision a flower, an animal, or any other symbol or image.

A caveat: some symbols, such as sacred geometry, have very powerful energy fields, so do your research and know what you are tattooing. Your tattoo should invoke an inner need for you to wear it and make a commitment to its permanency. This feeling of need

is a sure sign that your tattoo has a hidden message for you. Because symbols and images relate to archetypes and the elements of creation (fire, earth, air, water, and ether), you'll get a fascinating understanding of how you can create the desired direction of your tattoo's efficacy. Tattoos can be seen as vectors for your soul's journey and the symbols act as the trajectories for both the input and output of energy.

By the way, removing a tattoo from your skin still leaves a shadow scar on your consciousness that will remain from lifetime to lifetime as cellular memory—all the more reason to be cognizant of the hidden power held within tattoos. In this book, you will become familiar with the different types of body work and vibrational healing modalities that help you transmute the energy from a regrettable tattoo. You'll also learn how to maintain the sacred space on your body that holds your tattoo portal.

Your ink reflects the never-ending cyclical motif of death and rebirth. Tattoos are imbued with a mystical, transformative energy that births new ideals and resurrects long-held memories, even some from prior lifetimes. Getting a tattoo initiates a change that ripples throughout every layer of your being, from spiritual to physical and vice versa. Tattoos signify that you have crossed a threshold, a personal rite of passage that brings you to a different level of awareness. Your ink has a multidimensional, quantum, existential quality that can't be denied.

Through the years, I have recognized how my own body ink has acted as a portal for a deep spiritual awakening—hard to believe that a simple symbol could have such an impact on my life. It represents my embodiment for the abilities of lucid dreaming, astral travel, psychic receptivity, and the crossing of the threshold when I came into my own. I feel a deeper connection to prior incarnations and see my tattoo as something I have earned along the way of my soul's many journeys.

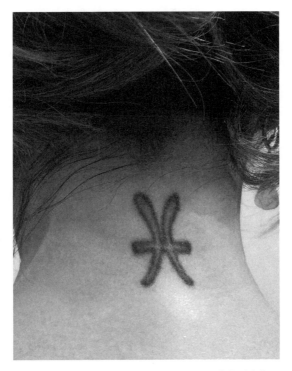

Tattoo by Body Graphics, Philadelphia.
Photo by Alison Barretta.

As you go through each chapter of this book, let it be an impetus for you to explore the power of consciousness and to become acutely aware of how tattoos possess an uncanny sentient side that can reach into the other dimensions, the realm of spirit. Whether you have one tattoo or a mosaic of tattoos, you can use this book to figure out the deeper meaning that goes beyond the ink on your skin.

If you are still deciding on whether to get a tattoo, my guess is that you will be making an appointment to get inked by the time you finish this book. I am inviting you to cross the threshold into the world of body art to explore the intimate, symbolic language of your spirit that is mysteriously veiled within tattoos.

I'm sending you good energy as you awaken the spirit within on your artful path to self-actualization and enlightenment.

CHAPTER 1

MORE THAN SKIN DEEP

Tattoos are more than just body art. They are a self-proclamation of one's consciousness, identity, and being. They are the outward manifestation of where the psyche meets the soul. The art has a spiritual or supernatural quality that surpasses normal comprehension. Looking at tattoos through the lens of consciousness gives you a new perspective, revealing their undeniable roots in pure magic, mysticism, and the ability for self-transformation.

In our society, which promotes individuality and self-expression, tattoos have made their way from subculture to pop culture. There is such an overwhelming interest in tattoos right now; they are no longer considered shameful but attract much positive attention instead. Images of tattoo art, along with photos of newly inked skin, are readily displayed on social media sites such as Instagram and Facebook. Generations ago, those who had tattoos were stereotyped as gang members, criminals, rebels, circus freaks, or undereducated. Women with tattoos—let alone the infamous "tramp stamp," a lower-back tattoo—were considered to be into sex, drugs, and rock and roll. Today there is no single *type* of person who wears a tattoo. People of all ages sport this edgy form of self-expressive art; the majority consists of Millennials and Gen Xers. Many successful startup companies are headed by men and women with tattoos, and some people view their tattoos as part of their individual fashion statements.

I wonder how many of us with tattoos are aware of the modern-day magic inked onto our skin. The origins of body art are closely tied to spirituality and mysticism. In some cultures, tattoos were considered a rite of passage, holding specific spiritual significance. They were given as badges of courage, served as talismans, and believed to perform a vital bridge between worlds. Today, many cultures still value the magic held within skin art, and serious consideration is given to a tattoo's design and placement, and who has the right to wear it. For instance, the animistic practices of the Shan religion, the

folk version of Buddhism, believe tattoos gain their power as they are being applied to the skin. The person applying the tattoo, a spirit doctor, then blows a spell into the tattoo.

So, you want to get a tattoo. What's the first step? Do you need a picture? A friend to go with you? No. The first step is to determine the intention behind your decision to begin the ritual. Yes, I did say *ritual,* because you are beginning a personal ceremony to celebrate yourself. It starts with your original intention, which readies the skin (or canvas) for getting inked. Tattoos are your personal story. The images, along with the colors you choose, form a resonance with the electromagnetic frequency of your aura and chakra system.

In a way that words many never convey, tattoos facilitate the outward statement for your inner desires to communicate the subtleties of your identity and your beliefs. Are you a badass who is into horror tattoos, or are you more the butterfly-on-the-shoulder type? What energy do you want to project or invite into your life? Tattoos have an ever-present mystical allure, whether they are custom-designed or a flash (predesigned) image, so it's important to be mindful about what it is you want to say about yourself visually.

A lot of people get tattoos that represent how they feel about themselves at a particular moment; thus, this becomes a permanent energy cord. For example, memorial tattoos serve as a remembrance to those who have passed and outwardly show the internal emotional bond to the deceased. Because of the significance of tattoos, getting inked should never be an impulsive decision. That crazy, drunken night when you decided to make a social statement will forever link you to the energy of that time. Before you ink up, take notice as to what you are imprinting onto your body. That cool skull and crossbones or screaming dragon may look good as art, but it may mark you as a magnet for a lot of conflict down the road. In a sense, you embody the intention and art you chose to ink onto your skin.

Now, you might think your ink is simply an image you like, but it is so much more than that. Tattoos are sentient art that become part of your consciousness. The tattooing process pierces not only your skin, but also your aura. Tattoos give off a charged frequency because of intention, color, metals in the ink, and placement on energy-sensitive body areas. These subtle frequencies attract attention and draw in similar frequencies through the open portal in your aura. Who would ever imagine that body art goes deeper than the skin?

Your tattoo, along with your intention for getting a tattoo and even the energy of your tattooist, penetrates into the layers of the subtle body. The subtle body is the energetic component of your whole being. It consists of interconnected layers or subtle bodies, also known as the auric field. Your aura or subtle body has seven layers or subtle bodies that are nested within each other. There are three physical plane bodies, three spiritual plane bodies, and the astral body. The astral body provides the primary means of connection between the lower and higher bodies. The lower three bodies process energies dealing with the physical plane, while the upper three process energies from the spiritual planes.

Each layer connects into the physical body via an energy point or chakra. The seven layers are as follows:

- **Etheric body** is the "blueprint" for the physical body. It transfers energy from the physical body to the various subtle bodies. *Who is doing your tattoo and what images are you placing on your body?*

- **Emotional body** is associated with your emotions and feelings. *Who or what is inspiring your body ink?*

- **Mental body** screens and interprets data from your mental process and thoughts. *Are you clear about your commitment to your tattoo?*

- ⛬ **Astral body** is the first of the spiritual plane. It sifts past-life experiences, genetic information, and karmic patterns, into your consciousness. It contains all the features of your personality. *Does your tattoo hold clues to your previous lifetimes?*

- ⛬ **Causal body** is the gate to higher consciousness. It links individual consciousness with the collective consciousness. *What archetypes are represented in your tattoo?*

- ⛬ **Celestial body** is the emotional layer of the subtle body. It is connected to your soul or higher self. *Your tattoo speaks the language of your soul.*

- ⛬ **Ketheric template** is the mental layer of the subtle body. It holds all the information about your soul and previous lifetimes and is where creative impulse begins. *Your inner most nudging for wanting and getting a tattoo.*

Your tattoo goes well beyond your dermis.

The body placement you choose especially influences the efficacy of your skin art. Certain areas on the body take in and expel lots of energy. Where you choose to ink your tattoo is significant in the language of energy. Your body has many chakras, or energy centers, aside from the seven recognized as the master cylinders linking the body, mind, and spirit. There are also 12 main meridians, and over 350 acupuncture points located along those meridians. Tattoos have a distinct effect on the emotional energies that are held within the parts of the body. The tattoo design and body placement should be carefully considered because they interface with the subtle body energy field. Your body is your sacred space, and where you put your tattoo is where you are putting your desires and holding energy points that give off a unique frequency. This is why your intention has to be clear, or you will be anchoring nebulous energy into your body, mind, and spirit. (More on that shortly.)

Your tattoo is powerful, and many religions realize this. This Bible verse from Leviticus 19:28 is often cited to make one wary of getting a tattoo: "You shall not make any cuts on your body for the dead or tattoo yourselves: I am the Lord." Sounds stark, but keep in mind that all of the major world religions have their roots in indigenous mysticism and pagan beliefs. They know the potential power in body adornment. It seems strong religious sentiment against tattoos is more for the fact that they don't want anyone to misuse the capacity for the image magic that body art retains.

Strict religious dogma against tattoos centers on the desires of the ego taking center stage and keeping the spirit backlisted. Per religious rites, tattoos entice demons who are attracted to the sexiness of tattoos, from the vivid colors to the provocative images. Tattoos pierce the aura, forming a portal for thought-form attachments to get into your subtle body. Some are good and some are negative. It's hard to deny the mysticism attached to tattoos, whether they are for self-expression or spiritual healing.

You can't walk away from body art the way you walk away from a painting or photograph because tattoos are a commitment that become a permanent part of you. Removing tattoos from your physical body doesn't remove them from the subtle body's retention. The memory remains, even when it is no longer visible ink. The pain, fear, uncertainty, desire, and design of the original tattoo are embodied into the subtle bodies as well. The open portal remains because of the piercing from the needles. Energy can't be destroyed, but it can be transmuted to a quieter frequency. In Chapter 7, you will get an idea of how energy workers help heal the trauma held in the subtle bodies caused by tattoo removal.

Sometimes we outgrow tattoos that no longer resonate with our energy, but we don't want to go through the pain of removal. The next option is to alter the original design. To modify an existing

tattoo, you have to consciously tie off the cords to past attachments, Reiki the area, and consecrate the adjusted design to be a portal that mindfully bridges the past to the present. It sounds crazy, but disconnecting from emotional memory is vital to transforming your beliefs and living your truth.

You possibly never thought of your ink as a calling card for energy hits and misses, but tattoos are powerful talismans, even the ones that you think are nothing more than silly designs. They are all imbued with powerful, manifesting, creative energy. Like everything else, tattoos are, at their most fundamental level, energy with distinct frequency. This book will give you a holistic, mystical, and philosophical perspective on the deeper meaning of tattoos, and affirm how tattoos tap into your energy field.

Everything starts with intention. If you believe you inked up just because you simply wanted a tattoo, then dig deeper, because there is an intention buried in there somewhere.

Mindfully choosing to be inked

Now that getting inked is more mainstream and many people don't think twice before getting a tattoo, there needs to be an awareness of how they link into your subtle body energy field. Your tattoo is going to connect you with something permanently, so carefully make your decision before going under the needle. Your intentions should be set beyond the watermark of vanity. Consider art that will enhance your frequency and fit into the framework of your beliefs.

A tattoo can represent a certain milestone in your life. A collection of ink can become a pictographic body map showing your experiences along life's way. Many people choose images that represent their profession, group affiliations, and names of loved ones. Some people identify with their animal totem (or spirit animal), choosing images that transfer the power of the animal onto their body and

into their energy field. Whatever you choose, the intention behind your choice will influence your consciousness in either raucous or surreptitious ways.

Intentions are such a powerful tool, and where we put our focus is where we create our experienced reality. I know a group of women who wanted to get tattoos of ribbons to support a friend who was battling cancer. One of the women in the group didn't want the tattoo. She felt there would be too much focus on the illness and feared co-creating it in her own body. As she realized, we embody our beliefs, and those can initially charge the tattoo.

Sometimes tattoos can shift your energy field into a higher vibration and make you feel better about yourself. For instance, you may want to camouflage a scar so you won't feel self-conscious. Intentionally looking for an invigorating image might lead you to choose a mandala tattoo inked with green hues to promote energy for healing. Meanwhile, art featuring sharp teeth, or something macabre, may feed the fear embodied in the scar and produce a frequency that incites the area instead of muting it.

Tattoos take on the vibrations from the intention, image, and colors you choose. Always be cognizant of the colors, which in themselves are expressed energy frequencies. Sometimes you will be drawn to colors that resonate with your aura, or be attracted to colors that your energy field needs for enrichment. Green is a good choice of color if you are a hyper type of person who is in need of some soothing energy. If you're looking to enhance your intuition, shades of purple can jump start your inner guidance.

Some psychologists think our desire behind getting inked has to do with social nonconformity, exhibitionism, or some underlying self-esteem issue. Looking at tattoos through the lens of consciousness, the desires and intentions behind body art are triggered by deep cellular memory. Tattoos serve as a window into the soul,

and the images we are drawn to may be links into the subconscious, dreams, or past-life incarnations.

On a deeper level, we are attracted to art that represents who we are, our most authentic self. We may be drawn to images that give us what we feel we lack and use the tattoo to enhance our own energy. Intention is the moving force behind the vibration of your tattoo and the emotion behind it lends a massive amount of power to its effect. Tattoos are multifaceted. They can initiate emotional healing, bring good (or bad) luck, shift some emotional energy, and reveal what is hidden in your consciousness. Their magical roots are ever present.

Meditation is a good way to focus and get clarity when setting your intention for getting a tattoo. I'm not suggesting you Zen out (although that is a good idea), but take the time to strongly imagine the tattoo energy on your skin. Burn incense, sage your space, creatively doodle pictures, and look at images to see what strongly resonates with you. Ask yourself what the tattoo will represent to you. Do you see it as a personal expression, or are you getting it just because other people will think it's cool? Does it embody an archetype with which you strongly identify, or are you exposing your shadow? Most importantly, how will your tattoo personally empower you? Don't kid yourself about tattoos, because they have a way of attracting energy toward you. The metals in the ink give the tattoo permanence, but in an esoteric sense, these same metals magnetize the design, leaving it a charged body talisman.

See your intention as the starting point of the tattoo ritual. Carefully determine what design you want inked, because creating art, in the mystical sense, has manifesting abilities. Imagery starts with what you see through the mind's eye that directly links into your consciousness. There is creative visualization involved in designing your tattoo, and it will carry the meaning you put into it. The law of attraction also works for tattoos, because what you intentionally set

into motion will attract the same thing back to you. Tattoos go beyond skin deep—they go *soul* deep. You purposely wound your skin to manifest an invigorating healing tattoo, or on the flip side, you wound your skin to show your inner hurts. In either case, tattoos are energy hot spots because the ritual of wounding the skin and drawing blood releases intense energy that becomes part of the tattoo.

Keep these points in mind as you contemplate getting inked:

- **Intention**: Always clearly define your intention.

- **Desire**: Do some soul searching. What emotions are propelling you to move forward with getting inked? Don't get a tattoo because you want to copy something you saw on someone else.

- **Purpose**: What does this image signify to *you*? Stay away from trendy designs and things that can be dated and soon out of style.

- **Permanency**: Will you still resonate and love this tattoo years from now?

Choosing your ink alchemist, the tattoo artist

Once you decide to get a tattoo, choosing the artist is more important than you may realize. Aside from looking at the quality of their work, the artist's energy essence will also be part of your tattoo. Getting inked is a very intimate experience. It is a spiritual vehicle for transmitting energy, because an invisible cord attaches the tattooist's energy to yours. Tattooing is a magical ritual that forms images, draws blood (our life force), and creates a symbolic bond between you and the artist.

The tattooist understands you are placing a permanent image onto, and into, your body. The initial consultation with your artist

gives you the opportunity to design your art and make sure your image fits your body contours. Your tattoo artist is, in a sense, a quasi-shaman performing a ritual. In fact, there are many tattoo artists who honor the transformative side of getting inked. They view it as a form of spiritual therapy that helps you express yourself in a creative way. Some shops really get into creating the perfect atmosphere for getting tattooed by expelling negative energy through playing shamanic drumming music and burning incense and sage. Some tattooists help you create a design, as well as select the location of your tattoo, based on your aura to enhance positive energy for you.

One type of tattooist you should avoid is a scratcher, someone who tattoos without any training, health code regulations, or the proper use of equipment. Keep in mind that from the metaphysical perspective, tattoos are an energy portal into your subtle body. Starting out with unacceptable conditions can mark you with a negatively charged tattoo that can cause a disturbance in your energy field.

Your frame of mind, as well as the artist's mood, should be harmonious because you will embody the emotional energy from the complete tattooing experience. If you are fearful, apprehensive, stoned, or drunk, all of those elements will manifest in your tattoo and become magnets for similar frequencies. Most people have a little fear during their first tattoo, but it can be readily transmuted with bodywork or Reiki. Drugs and alcohol are substances that induce unfocused emotional states that weaken and alter your aura, making it easier for negative energy to get in and take root. A lot of tattooists will refuse to ink you if you are obviously under the influence of drugs or alcohol.

Your tattooist will be imbuing their energy into your subtle body, so be cognizant of what you are sensing from them. What if they are

aggravated, emotionally unbalanced, or in a bad mood? Also, don't insist on a design that they are not comfortable inking onto your skin. Do you really want that energy tagged into your tattoo? A tattooist I had a conversation with a few years ago told me that she refuses to do face tattoos because, at some point, most people regretted getting inked on their face. She emphatically said, "I never want anyone to hate me for marking their face. All those bad vibes directed at me would be like a curse."

While I was gathering information for this book, my Reiki master put me in touch with a very interesting tattooist, Josh Adair. Josh is a musician and a tattoo artist who gave me the inside details on how most people chose their tattoo art. Josh said, "There is always a story behind their tattoos. A lot of people come in and describe dreams that they had, or maybe some sort of vision. I don't think I ever did a flash image because all of the work in the place I work is custom." I asked him if it was hard to interpret someone's dream image. He replied, "Not really. I feel like I just start to channel what they want, as if it comes to me from the spirit world." My conversation with Josh verified that there is definitely a transference of energy that takes place between the artist and the client.

I pressed further and asked Josh if there are any tattoos that he really doesn't care to do. He told me that anything too dark—"dark" as in horror—creeps him out. He also doesn't like writing messages. Josh explained, "When I am asked to write words on someone, I keep thinking about that water experiment that Dr. Masaru Emoto did when he typed out different words, both positive and negative in meaning, and taped them to containers full of water. The positive words made a difference to the water's structure, and since we're mostly water, it made me wonder what effect it had on people who want sayings tattooed onto their skin." I found this to be interesting insight and the point well taken.

Here is a bit of amusing information that Josh passed on to me about tattooing names onto your body. Evidently, tattooists are superstitious about inking your lover's name, because it means that you will eventually break up with that person. He also told me that there are tattoo trends; a lot of them seem to be greatly influenced by pictures posted on social media. It's as if everybody is consciously connecting into the same thing at certain times. Josh told me that the ouroboros, the infinity sign (∞), was real big for a while, signifying never-ending love. Then there was the popularity of the semicolon symbol, which is for suicide awareness. Aside from the trendy tattoos, Josh said, "It is hard to say that tattoo designs have a blanket meaning, because they represent something very personal to each individual because they tap deep into their consciousness."

What's the most intense aspect of tattooing, per Josh? The people. "Man, some of them can really wear you out with all of their nervous energy, fidgeting, questions, and behavior. Sometimes the people coming in and out of the shop leave behind weird vibes."

That brings up another vital point in getting tattooed: the shop. Because a tattoo business is heavily focused on art, craftsmanship, and energy, the atmosphere of the shop is also embodied into your tattoo.

The tattoo parlor: A haven for anthropomorphic energy

Once you finally decide to take the plunge, you should also carefully choose where you go to get your tattoo. You may be somewhat prepared for a little pain or possibly a design that doesn't turn out exactly as you had envisioned, but you most likely didn't give too much thought to the safety of your energy field. You not only absorb the energy of the tattooist, but also that of the parlor, a harbor for residual energy left behind from other people getting inked. Their

excitement, fears, and desires are all components of highly charged energy, so much that you can almost hear the walls talk. Emotional energy is very transmissible, and you can unknowingly take it into your subtle body.

The emotional energy lingering in some tattoo shops has perceptible qualia that you can sense as either a good vibe or a foreboding feeling. You have to be discerning in where you choose to go get inked. Residual energy accumulates in places with lots of high human traffic and places where lots of emotions are expressed. Tattoo shops are no stranger to having their share of anxious, fearful, stoned, and sometimes disturbed people coming through their doors. The energy given off by the clientele, or possibly the tattooist, lingers like a sticky web and clings to everything in the shop, including the people passing through to get tattooed. People who are stressed, nervous, or overly emotional cause their aura to weaken, and energy easily leaks out and becomes residual energy in their surroundings. The subtle sensation is similar to when you walk into a room where someone had an argument, and you can feel the vibes in the air even though you weren't present. Negative residual energy gives you a distinct hit, usually in your gut, the solar plexus chakra.

You will know if you took an energy hit from a visit to a tattoo shop because you may feel drained, experience negative emotions, or find that you overreact to any emotional situation. Headaches, anxiety, and panic attacks are also signs of a negative energy encounter. Always sense what you intuitively feel when you walk into a tattoo shop, because the energy inside speaks volumes, if you are aware of it.

There are some tattoo shops that are geared for the deep, spiritual essence of getting tattooed. They focus on mindful tattooing. Tattooists in these shops realize that the piercing of skin can stimulate the movement of *chi* (energy) within your body, and release

heavy emotional energy. Early cultures were all very aware that piercing the skin stimulates energy held in the body. Tattoo artists who approach inking from a more spiritual angle understand that your subtle body also registers getting tattooed. Tattoo needles pierce the aura—the energy field that surrounds your body and emanates energy—and rattles your inner vibrations. The emotional memory of the experience is imprinted on the consciousness.

Mindful tattoo artists ascribe to keeping the original philosophies of the indigenous people who believed adorning the body with tattoos would help connect us to our spiritual essence. Tattooing has aspects that go deeper than the art. The pain from the needle can trigger past traumas held within the consciousness, even those associated with past-life experiences. The energy vibes you get from shops that consciously tattoo are more relaxing and spa-like. This type of shop usually attracts people who resonate with that sort of energy.

∽

Once you get your tattoo, the tattooist will tell you how to treat the area you had inked. Aftercare from getting a tattoo is important so you don't get an infection, but artists usually don't mention the deeper subtle body layers that also need care. There are things you can do to ensure you don't take on any unnecessary residual energy from your inking experience. It can be the energy from an overly active shop or even your own apprehensions and fears. The following practices are good to do both before and after getting inked:

- Take a sea salt bath or soak your feet in sea salt to release any negative charges from your body.

- Sage yourself and direct the smoke mostly toward the area to be tattooed.

- ❧ Wear a hematite ring or carry a piece of hematite. It repels negative energy and also helps keep bleeding under control.

- ❧ Treat your tattoo as sacred body space and be mindful that it is an active energy portal.

In Chapter 2, we'll explore the energy zones of your body so you can decide the best place for your tattoo.

MODIFICATION OF THE BODY AND SPIRIT

Tattoos are something you are going to wear and stare at for a long time. Once you decide to get a tattoo, it's a good idea to familiarize yourself with the body's energy zones and how they interlock together as one consciousness. When you physically get a tattoo, it also becomes an energy imprint into the layers of your etheric body. The phenomena that the body, mind, and spirit are not separate, but one functioning system, is something that still baffles science.

Looking at tattoos solely through the lens of the physical world, the commitment to body modification also carries some concerns regarding the potential to get an infection, have an allergic reaction to the ink, contract hepatitis, or develop other complications from the tattooing process. Of course, there is also the pain from the needles that can run from mild to severe, depending on the area you choose to ink. Some may wonder if getting tattooed goes deep enough into the skin to upset any of the acupuncture points on the body. Even though tattoos may lay on these energy points, the needles don't go in as far as acupuncture needles, but the intention, image, and ink color, in a holistic sense, influence the energy vibration around these points.

Your consciousness is animated through the physical body, which is a vehicle for the mind and spirit's expression in the outside world. Your skin is the largest and most sensitive organ, and in the language of body energy, it shows your sensitivities to life. Tattoos can bring amazing insights into the state of the body, mind, and spirit. Your physical body areas convey certain messages in the language of energy. Where you ink a tattoo will signify particular ideologies; for example, the back is where we carry the burdens of life. What images are you imprinting on your back? What is the cryptic message that you not only embody, but also express outwardly? The intention, plus the art, attracts similar energies to the area where it is placed and can also activate stored energy.

Where you choose to get inked will be discussed with your tattooist. The body area is usually determined by where the image looks best. You may have a certain area in mind, but you should take a step back and closely listen to your instincts. Your consciousness directs where on the body the tattoo will find its best resonance. Putting something where it doesn't belong eventually causes an energy blockage. This may seem foreign to you, but everything is consciousness, even the images you wear. Mindfully tattooing can enhance your energy field, instead of wearing it down by decreasing your body's vibration.

To put it in other terms: a house has many rooms, each designated for certain functions (kitchen, bathroom, dining room, etc.). If you put a dining set in a bathroom, it won't resonate with that space, no matter how beautiful the furniture. It fights the energy that wants to be expressed in that area. Additionally, when decorating homes, one takes color into consideration. Colors imbue vibrations into a room; for example, a red room has a more active energy than a cool blue room. Moreover, cluttered space holds too much energy and breaks the flow of *chi*; this can be draining. Putting something where it doesn't belong will cause stress, and its energy will ping off of everything else. I think you get the idea.

The wrong tattoo placement, design, and colors, along with too much going on in one space, can overload your body's energy field. This will either block your *chi*, or make it extremely overactive and draining. For instance, say you decide on a tattoo sleeve. It is better to have images that unfold into a cohesive pattern of energy. Include consciousness along with aesthetics when deciding where you want your tattoo to be inked.

When choosing to decorate your skin with body art, you will get better results if you do it holistically, from the perspective of body, mind, and spirit being one unit. Sometimes karma from a prior life

experience will inspire you to place a tattoo on a particular body area. This happens because of subconscious memories from past lives that come up again and want to be released in the current life. The images you ink in this incarnation will remain in your subtle body field and become part of your consciousness. (Too many dark images can unfold into your next life experience and possibly manifest unwanted situations and conditions.) Always ask (yes, *ask*) the image before inking it onto your body if it is for release of something you are holding in your subtle body field, or a current expression of your present mindset. You will feel the answer and then be pulled to where the tattoo will be best expressed on the body. In an intuitive way, your body directs you to the area where your arty inspirations feel most at home.

Everything held in your consciousness is realized through the physical body, whether it is a talent, disease, addiction, or other strong experience. Tattoos are not only a form of self-expression, but also an intimate way to express yourself to the outside world. Tattoos cryptically reveal your inner soul. They give insight into your spiritual self, hint at past lives, and suggest what you may be attracting toward your future. Tattoos link into your consciousness, and the body is the drawing board that displays your inner mix of archetypes and shadows. Tattoos that are primarily geometric or tribal designs express their meaning through color, shapes, and symbols. Lettering, phrases, and words inked on your skin also have very potent meanings. They can be stronger than traditional images because they are more definable. When you ink on phrases or words you are clearly defining *yourself.*

Choosing an area of the body to tattoo simply because the art will look good in that space should be part of the decision; however, keep in mind what doors you are opening into the subtle realms of your essence.

The subtle body infrastructure and tattoos

It may surprise you that emotions are not solely stored in your brain, but throughout your body. Any emotional energy we don't fully experience and process can get trapped in the body. The piercing of the skin stimulates energy, similar to acupuncture. Believe it or not, tattoos can either assist in release of trapped energy or possibly aggravate it. It's a good idea to become familiar with the body's preference for expression. Tattoos on an uninviting body space can shift your energy in undesirable directions and upset your *chi*.

Tattoos that reflect how you feel about the *now* are, in a mystical sense, drawn to being placed on the right side of the body. This is the side of the body that reflects how you feel about your current life experiences and is governed by your logical left brain. It's where things we are currently passionate about are comfortably expressed.

However, tattoos that want to be inked on the left side of your body connect to your mystical side, where you, possibly unknowingly, want images of objects you are intuitively drawn to, along with images of things that are dear to your heart. This side of the body links into the emotional, vulnerable right brain, which displays our emotional connection to our inner self and wounds. The creative, intuitive voice of your soul is instinctually revealed instead of logically planned.

Tattoos on the front of your body reflect your social mask, how you want to be perceived as you move through the outside world. It represents the conscious part of us and the future. Front-facing images hold clues to the archetypes you identify with on a day-to-day basis. Alternately, tattoos on the back of the body reflect the past, where you draw strength from experience, and even hint at an awareness of prior lifetimes. They can cryptically contain archetypes that relate to the emotional burdens you carry and the strengths you need to draw upon to help carry the load.

Because we are looking at tattoos from the holistic perspective, the list below gives insight into body areas and the emotions they express. Intention and images that resonate with the body enhance your aura, whereas tattoos that fight the energy may eventually cause energy blockages, weaken your aura, and attract more of the wrong energy via thought-form attachments. The body's zones and their expressed emotional energy are:

- **Brow:** Intuitive center, deep emotional expression.

- **Forehead:** Intellectual expression.

- **Face:** Expresses the various "masks" of our personality, shows how we face the world.

- **Behind the ears:** The portal for past-life experiences and what we remember from other incarnations.

- **Ears:** Listening to guidance.

- **Throat:** Communication and speaking our truth.

- **Neck:** Where thoughts and emotions come together.

- **Shoulders:** The burdens we carry.

- **Chest/torso:** The place for your private self: your relationship issues, heart and love emotions, self-esteem, and feelings of worthlessness are held here. It also holds our most private wounds.

- **Arms and hands:** Connections to the external world that also show what you embrace. Who or what you are holding on to? Or, what do you want to let go?

- **Armpits:** Storage unit of what we don't want to see anymore.

- **Upper arm:** Shows strength.

- **Forearm:** Your goals and what you go after in life.

- **Wrist:** Capacity to start and complete something that has already been accepted.

- **Hands:** Associated with giving (right hand) and receiving (left hand). They represent holding on to reality, reaching goals, and how you handle issues or situations.

- **Fingers:** The fingers of the right hand are how you purposely express the associated qualities of each finger; the fingers on the left hand show how your intuitively approach these qualities along with your individuality:

 - **Thumb:** Flexibility.

 - **Index finger**: Assertiveness and power.

 - **Middle finger:** Ego and ambition.

 - **Ring finger:** Outer beauty and harmony.

 - **Little finger:** Confidence and self-awareness.

- **Back:** Where we store our unconscious emotions, the past, and past-life experiences. Tattoos here show what you need to feel supported.

 - **Upper back (between the shoulder blades):** Where anger is stored. Tattoos can reflect unresolved anger issues or be images that help us resolve our inner conflicts depending on what image energy you choose to embody.

 - **Lower back:** Where our outward expression to the material world is conveyed, including sexuality.

- **Abdomen:** The seat of emotions, which contains our deepest feelings, the center of sexuality, and our gut feelings toward life.

- **Hips**: Hold the energy for moving forward in life, so ink images that pull that energy in the right direction.

- **Genitals**: Where we hold the energy for survival, sexual energy, and fears.

- **Buttocks**: Where we hold emotions.

- **Abductors (inner thigh)**: Contains sexually charged issues.

- **Thigh:** Personal strength, trust in one's own abilities, and energy for our decisions.

- **Knees:** Show our pride and flexibility. Images on the knees pull in energy for self-respect and the ego.

- **Lower leg:** Expresses movement toward goals and also what we leave behind as we move forward.

- **Ankles:** Convey balance and what we need to feel supported.

- **Feet:** Our expression toward security and survival, and the steps we take to feel grounded.

- **Toes:** Toes are high energy areas and each toe expresses a certain quality of self-expression:

 - **Big toe:** Right is joy; left is sorrow.

 - **Second toe:** Right is wishes and desires; left is emotions.

 - **Middle toe:** Right is aggression; left is creativity.

 - **Fourth toe:** Right is attachment; left is love.

 - **Little toe:** Right is fear; left is trust and sex.

If you are thinking about getting inked or already have tattoos, the body's vibrational voice helps you realize the deeper meaning to

your body art and gives you awesome insight into the many layers of your consciousness. Mindful tattooing can enhance the meaning behind your body art, more so than an impulsive urge, which pushes you toward getting a tattoo you later regret having on your body. Consulting with your tattooist, deciding on the design you want, declaring your intention for the tattoo, and carefully considering body placement are all very important, but you should also seriously consider the colors to be used.

The magic of color

You may not realize it, but colors have a huge influence on the body's frequency. Unfortunately, it is most likely an aspect that is rarely considered beyond the aesthetic appeal of a color. Color evokes innumerable feelings, and it is experienced not only visually but also as a distinct frequency that either attracts us or repels us. Color is yet another form of expressed energy and represents the intangible emotions of our consciousness. Tiny electrical impulses in our body result in the formation of a magnetic field around our body, also known as the aura. Its shape is similar to an egg, and it contains information related to the physical, emotional, mental, and spiritual body.

The body has seven main energy centers, called chakras, which pull in, interpret, and release vibrational energy that matches up with color frequencies. The aura shows colors because the subtle energy bodies are vibrating at different oscillations. The colors change like a mood ring, depending on the state of your emotions and feelings. Sometimes if we are low in energy for a particular part of the body, we are intuitively drawn to a certain color because we need its vibration. If your frequency is too high, and you feel scattered, then you are pulled toward more calming hues.

We are attracted to colors that resonate with our personal frequencies and tend to build around those colors. For example, you change your clothes regularly. The colors you wear on any given day have an effect on your mood and, in a subtle way, influence how other people perceive you via color frequency. Mostly everyone views a black suit as a power suit, whereas pink clothes evoke feelings of kindness and empathy. The colors you choose for a tattoo will also have an influence on your body's vibration, but you can't change it like you change your clothes.

Your body's energy field contains the colors of the rainbow, along with varying degrees of those colors. Each color links to one of your chakra zones. Having an idea of where colors find their best resonance can help you consciously choose the inks for your tattoo. Remember, tattoos are permanent, even after you have them physically removed, so keep your subtle body anatomy in mind when picking colors for the image.

The body's color resonance field is as follows:

- **Lower body (from the navel down):** Shades of yellow, orange, and red for enhanced energy; purple, blue, and green to calm excess energy.

- **Torso:** Shades of green or blue-green, for enhanced energy; red and pink to calm excess energy.

- **Neck, arms, and hands:** Shades of blue to turquoise for enhanced energy; orange to calm energy.

- **Face and head:** Indigo and violet for enhanced energy; red and yellow to calm energy.

You can use any color tattoo ink on any part of the body, but using colors that match or enhance the body's frequency will give you better resonance. Black helps insulate your tattoo from absorbing negative energy, but too much black may muffle the vibration of

the tattoo, and the body area where it is inked may stay in a lower frequency. Darker-hued tattoos are often more of a reflection of someone's deep personal journey. Some people wear their shadow on the outside and are comfortable in a lower vibration, so their ink is less colorful. White tattoos are becoming trendy; they also bring peace and harmony into your energy field.

Everyone has their own personal color vibration. The frequency you need finds its way into your tattoo. Below is a list showing the nature of different colors based on their frequency. Shades of a particular color will either intensify or lessen the effects the color has on your body's energy field.

The meanings of colors are:

- **Red:** Life force, sex, survival instinct, passion, anger, anxiety, nervousness.

- **Orange:** Sensuality, physical pleasure, emotional self-expression, creativity, impulsiveness; can also indicate an outgoing social nature or stress related to addictions.

- **Yellow:** Mental alertness, analytical thought, happiness, optimism.

- **Green:** Healing, peace, nurturing, new growth.

- **Blue:** Depth, stability, trust, loyalty, calmness.

- **Indigo:** Spirituality, spiritual truth.

- **Violet/purple:** Wisdom, authority, intuition, spirituality.

- **Pink:** Playfulness, compassion, nurturing.

- **Brown:** Practicality, earthiness, grounding.

- **Black:** Power, mystery, shadow games.

- **White:** Purity, innocence, spirit.

Colors can give different meaning to your images and better express your intention behind your tattoo. An image that would normally be considered macabre can take on a completely different meaning if it is imbued with colors that give off a soothing frequency. Every tattooist I spoke to agreed that the initial consultation prior to getting permanently inked is vital in order to achieve desired results. During this session, they may suggest colors that look good for your art; be sure to choose colors that resonate with your frequency.

You might see tattoos you like on other people, on social media, or in tattoo books, but they might not be the right images or body placement for you. Just because a tattoo looks awesome on someone else doesn't mean it'll be a good fit for your body's energy field. It's like seeing a great piece of art but it doesn't fit the motif of your home, or a haircut that looks good on someone but doesn't quite work for you.

Tattoos and the chakra system

Tattoos can shift the balance of your energy. They hold a dialogue with you that can be very healing and empowering, as long as they speak of your truths. When you decide to get a tattoo, there is an accompanying emotion that is very personal to what you feel at that time. Every tattoo will emit a different kind of energy that interplays with your chakra system.

Your chakras are part of your spiritual anatomy and process emotional energy. Each chakra influences a particular region of the body. They stream emotional energy throughout your system. They are like spark plugs in your car: if one is not firing properly, then the condition of the system is compromised. Most people with tattoos probably never gave the chakra system a thought, if they even know what it is. If you're not into spiritual anatomy, it doesn't mean your chakras won't influence or be influenced by the intention attached to

your tattoos. Intention is what we desire, and desire invokes an emotion. Chakras process and store emotional energy related to the perceptions of your experiences, even those from prior lifetimes. Your tattoo symbolizes the outward expression of what you embody.

What *is* a chakra anyway?

Chakra is a Sanskrit word that means "wheel." Chakras are spinning energy centers that exist in our subtle etheric body, the counterpart to our physical body. They vibrate at different levels, open and close, and are very sensitive to emotional energy that either stimulates or blocks their flow. Each chakra is associated with a certain part of the body. The seven main chakras are located along the central line of the body, from the base of the spine to the top of the head. They are also located in the ethereal body, and they express the embodiment of spiritual energy on the physical plane.

Aside from the seven main chakras, there are many smaller ones covering basically every area in and on the body. Chances are that when you get inked, you will be piercing the skin on or around either a major or minor chakra. Many of the smaller chakras are insignificant, except for the ones on the hands, feet, and fingertips, which have significant functions. The chakras on the feet pull in additional grounding energy, and the chakras on the hands transmit energy, especially healing energy. This energy movement throughout the chakra system determines our state of health and balance.

When you get a tattoo, you are opening a portal and stimulating the energy held in that area. The chakra centers are like a 220-volt line into your consciousness, and chances are you may be activating long-held emotional energy from other lifetimes. When the initial endorphin rush from getting inked wears off, some people may feel oversensitive, emotionally depleted, or zapped from energy pings. This is due to the storm of emotions that were stirred during the trauma from piercing of the skin and aura. There is no separation.

The body, mind, and spirit are all one in consciousness, and what happens to one layer happens to all.

The first chakra, called the root chakra, is located at the base of the spine. This chakra opens downward and relates to the energy of survival. How grounded are you? Think about tattoos that express your attitude regarding how secure you feel in the world. You function primarily from this chakra until about the age of seven. Stimulating energy in this area may bring up childhood memories and even visions from past lives. You may start to feel a connection to other lifetimes or ruminate through the past. This is where you store a lot of emotional energy for things that tip your feeling of being safe. The fight-or-flight emotions can get stirred up.

Your second chakra, the sacral chakra, is located just beneath the navel and opens forward. It's the chakra associated with sexuality, sensuality, and pleasure. Anyone you have ever had sex with can leave some of their energy field in your sacral chakra. The second chakra finds expression in your creations, your children, your passions, and even in the tattoo art you create for your body. When piercing the skin in the area of this chakra, you can stimulate repressed energy that has to do with control issues, sexual hang-ups, and emotional drama. This chakra is also associated with your attachments and any addictions you may have. Before tattooing near this area, set a clear intention to avoid negative thought-form creations and dependency issues.

The third chakra, the solar plexus chakra, is located near your navel. The energy from this chakra flows upward and shifts the energy from the earthly, primal connections of the lower chakras to the higher group of spiritual chakras. This is an area that holds your psychic sense, intuition, and gut feelings. Tattooing in this area can stimulate how you use your personal power. Tattoos that don't resonate with this chakra center can hinder your perception of life.

Before inking in this chakra zone, form a good intention, meditate, and ask this sensitive energy center what type of tattoo belongs there.

The fourth chakra, the heart chakra, is located near—you guessed it—the heart, and it opens forward. It's our center of unconditional love and the seat of all emotional memory. Tattoos in this area usually represent what we hold dear to our heart. Opening a portal in this area can stimulate the emotions, and you may have a release of epic proportions. You may suddenly want to discharge all of your most private wounds. Images placed in this area speak volumes. This is where we express our truths.

The fifth chakra, the throat chakra, is actually comprised of two separate chakras: a larger one located between the depression in the neck and the larynx, and another, smaller chakra that opens to the back. Because these chakras are so close together, they are integrated into one as the throat chakra. It expresses your energy for communication, inspiration, and manifestation. Piercing the skin opens the portal for your thoughts and emotions to come together. As many mystics already know, the spoken word has a great deal of manifestation power. Stimulating the energy in this area can make you overly expressive, to the point of blocking out your inner voice.

The sixth chakra, the third eye chakra, is located above the bridge of the nose in the center of the forehead, and opens to the front. Commonly referred to as the third eye or clairvoyant eye, this chakra is considered to be the seat of our higher mental powers, where our ESP links in to the physical body via the pineal gland, a tiny, pine cone–shaped gland situated deep in the brain. In some cultures, this chakra is believed to be the seat of concealed wisdom and is represented by a mark on the forehead known as a *bindi*. This special mark has been used for almost 5,000 years, and is mentioned in India's oldest text, the *Rigveda*. Tattooing in this chakra area can trigger abilities that are associated with telepathy, connecting into

parallel lives, and clairvoyance, also known as psychic sight or the sight of the soul. Stimulation of this chakra can also bring about lucid dreaming and out-of-body experiences. This is one chakra you have to effectively open and close. If this center remains open and unprotected, it is possible to leave yourself vulnerable to psychic attacks. This is an intense energy vortex where psychic impressions are always conveyed via emotions.

The seventh chakra, the crown chakra, is located at the middle of the top of the head and opens upward. The crown area is the portal connecting us with the ever-increasing frequencies of the expanding universe. In religious paintings, the crown chakra is often represented as a halo, indicating where our own personal energy connects into the divine energy of the universe. Opening the crown chakra to the wrong vibrations—or, conversely, not closing it completely at critical times—may leave you vulnerable to an influx of negative energy. Stimulating energy in this area with a head tattoo can resurface emotions from each of your prior lifetimes. These subtle memories and emotional patterns can help you discover why you are the way you are in this life. An emotional blockage in this chakra comes across as a tendency to intellectualize everything, display spiritual cynicism, and feel separated from abundance. You may feel a lack of purpose. This chakra is overactive if you are only concerned with spirituality while ignoring your worldly needs. There is also a tendency to have episodes of "spacing out" momentarily because you've been downloading more energy.

The foot chakra helps ground us. Being the last point of energy and the last part of us, the foot chakra is considered as one of the most important chakras. This chakra is split between the two feet, located at the ball/arch of each foot. Even though it is located on each foot, it is still considered just one chakra. This is a place where our divine energy returns to the divine source. The foot chakra can also act as our energy transformer and regulates the quantity of energy

needed for good *chi* flow. Emotional energy held in the thighs (energy for our decisions) can influence this chakra. It qualifies if you feel grounded enough to move forward in life. The right foot is about moving in a planned-out direction and very conscious of time and space restrictions. The left foot intuitively and creatively moves into the flow and direction of life. Tattoo energy inked onto your feet influences how you will walk through life, as well as your sense of security.

The hand chakras are numerous. You have many chakras on your hands and fingers but the primary ones are located in the center of the palms. They open and close to receive and send out energy. They connect into the emotions held in the arms and express what you emotionally embrace. When the flow of energy in the hand chakras connects into love, healing energy can come through, as in Reiki. They are associated with the act of giving and receiving. When these chakras are out of balance, it can make you hesitant to ask for help. The right hand chakra resonates to what you go after in life and the left hand chakra vibrates to what you intuitively feel. Tattoos on the hand impart an energy that influences how you touch and feel about life.

Tattoos representative of chakra symbols are very popular and powerful. They stimulate the energy connection between one's body and spirit, as well as promote a state of harmony and peace. Having knowledge of the subtle body energy system helps you understand what chakras relate to emotions that may need healing or what chakras are in need of a boost.

Here is a good idea to keep in mind before getting a tattoo: visit a body worker. A masseuse or Reiki practitioner may help you identify where you have a buildup of excess, unexpressed energy in the body. This gives you additional information to help you decide the best image, color, and placement for your ink. Approaching tattoos

from the inside out opens an invigorating dialogue with your body, mind, and spirit.

Your ego may try to convince you that something is good, but your body doesn't lie. It knows what it wants and needs. Having awareness of the subtle body system will give you a new perspective on tattoos and their capacity to shift your energy.

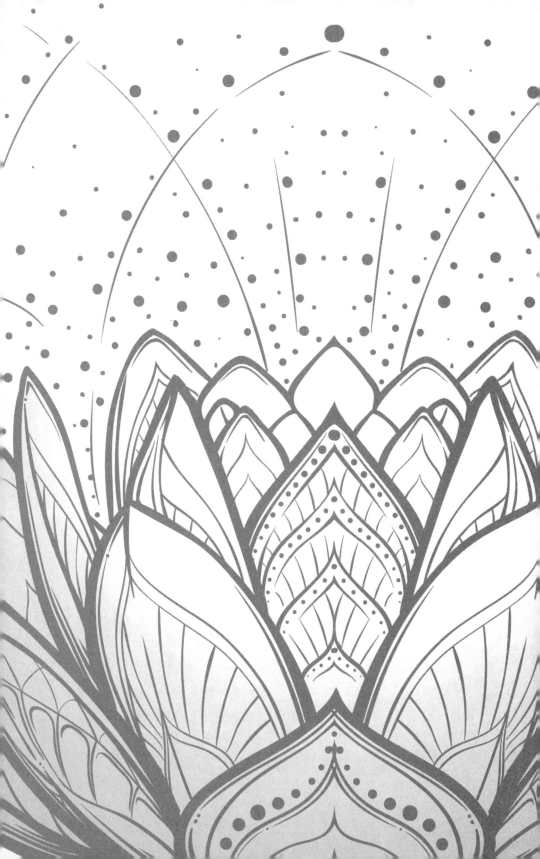

Tattoos Through the Lens of Consciousness

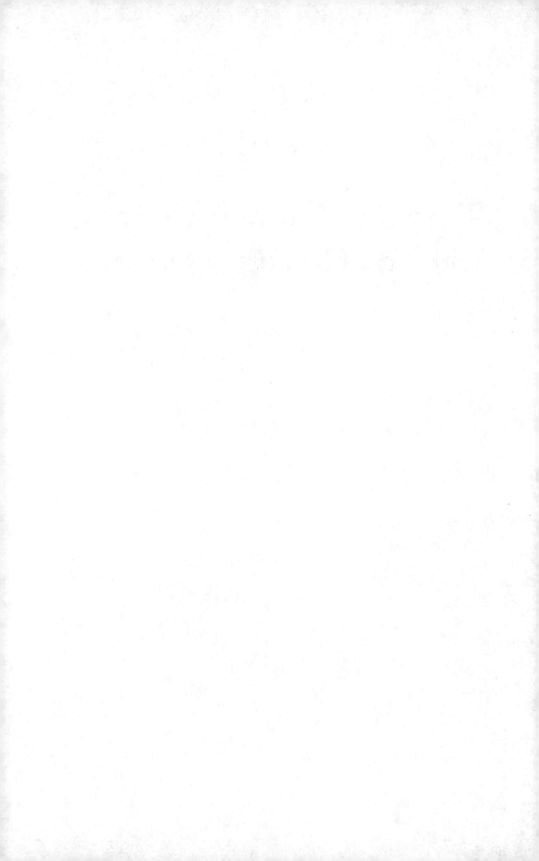

Consciousness is the intangible part of our being. It stores every bit of information about who we are and holds the blueprint for where we are headed. It is the sum of your spirit's evolutionary development. Every minute, the cells of your body are updating and recording information. Our cells remember all of our past lives and everything that has happened in this lifetime right up to the present day. This is what's known as *cellular memory.*

Believe it or not, your tattoo, and what it represents, is also captured in your consciousness. It is immortally etched into your cellular memory and will either enhance or lower your vibration, based on the intention and emotions imbued at its creation. Your ink may even represent something from another lifetime that has come through for review. The Maori, along with other Polynesian groups, believe a person's spiritual efficacy, or life force, is displayed through their tattoo.

Tattoos can effectively help you explore the deepest layers of your consciousness and bridge the gap between your conscious mind and the spirit. The images you have inked on your body create visual stimuli that evoke emotional release. Many times, these images reveal themselves via impactful dreams. These dreams may bring a regressed memory closer to the surface for healing. Quite a few tattooists I talked to told me many people want a tattoo that represents a specific dream. Very often through dreams, the subconscious mind uses a past-life story as a means of symbolically bringing forward vital information that needs to be processed. Childhood memories, the nine months in the womb, and even other incarnations are forever held in the essence of consciousness.

Dreams can also inspire you to face your fears, bring out your hidden potential, and give you a glimpse into the future. Whatever inspires you to get a tattoo, know there is a hidden meaning that is personal to you. Consciousness is creative, and that creativity is

expressed in myriad ways. Tattooing is an amazing modality that awakens your spirit—if you dare.

Because tattooing is rooted in shamanism, it also subscribes to the philosophy that there is no separateness. Your physical reality is just a layer of consciousness. Images you are intuitively drawn to hold more information about your true self than you may realize. There is a deep, personal resonance you instinctively feel. You may think you are just inking something *on* but you are also bringing something *out* that is linked to an emotion, memory, or trauma. Emotional memories are powerful and serve to guide and inform you. An image that visually speaks a personal dialogue with you is telling you something about yourself.

Many people who shun traditional forms of therapy find that getting a tattoo is an appropriate, satisfying way to express their emotions. Getting inked allows you to explore, express, and find your hidden pieces without spending endless therapy sessions (and money) talking about it. Like Aristotle said, "Knowing yourself is the beginning of all wisdom."

Your consciousness, in a mystical way, urges you toward tattoo images that are curative. Even dark image tattoos serve a purpose. They bring your shadow and fears to the surface. A nemesis can be a vast part of the story for many awakenings. The happy, playful tattoos you ink may be a clue to your inner child. Tattoos of a lighter nature coax your carefree nature to come back to the surface. You may be so caught up in the grind of work and the material world that you don't take time to find joy. A new awareness can be birthed from getting a tattoo.

The spot on your body that you decide to ink is where your chosen image will hold space. The phrase *hold space* is a term used quite often in transformative healing work like Reiki, therapeutic massage, and other holistic therapies. The inked area becomes a portal

on your body where an emotional expression can come through as an affirmation for what you find meaningful. When you consciously tattoo, you are establishing that the intention, emotion, and image exist on all levels of consciousness without judgement. The tattoo symbolically marks the place on your body where you are able to hold space and be honest about who you are.

Conscious ink is without ego, because it is from a deep inner connection with meaning. The ink on your skin lives and breathes along with you. It is sentient. It will *feed* you emotions and *feel* your emotions. The tattoo reminds you to be present with yourself, and it holds that protective space for you.

Consciously tattooing is about much more than bringing an image physically onto the body. It can conjure a whole range of un-expected and sometimes difficult emotions. When energy is stim-ulated on the physical body due to the tattoo needles piercing the skin, its counterpart held in the subtle bodies is also awakened. A stream of information is exchanged throughout the entire system, resulting in the movement of emotional energy. One of the most re-warding aspects of consciously tattooing is that it can be the perfect modality to become more aware of those emotions so you can begin to work through them. Tattooing stimulates your energy, which in turn initiates change in your consciousness.

The pain experienced when getting a tattoo can be a pathway to spiritual identity. Pain causes a shift in your awareness. This com-plex process is executed on many spiritual levels, through every layer of your subtle body. When getting inked, the needles penetrate your body and aura. This is a form of trauma, and your body responds in kind. It recognizes the wound and begins to heal. In the subtle body, a deeper healing is experienced and the pain may be released through emotions. Often, letting go emotionally is more raw than physical pain.

Endorphins are released during a tattoo session. They are your body's natural pain relievers. These chemicals come directly from the brain, flooding your body. Endorphins are feel-good chemicals and help us realize, on some level, that we are more resilient to pain than we think. Your body also releases endorphins right before you die to ease the transition from the physical world to the afterlife. In a sense, we can theorize getting a tattoo signifies to your consciousness that a shift is taking place. There is a metaphoric death and rebirth within yourself.

After you get a tattoo, pay attention to how you emotionally feel. Tattoos can trigger buried feelings that rise to the surface for release. It either happens right away, or the effects of the shifting energy kick in weeks later. You may be thinking, "Wow! No way!" But it's true— you just need to be present and aware. Listen to what your body is conveying to you.

When you understand how something works, you are able to experience everything it has to offer. Tattooing is no different. If you just get some random tattooist to put a flash image on you or some impulsive design, you may be limiting yourself to an extremely reduced experience. You will not have full awareness of its effects on your consciousness. It's like buying a ticket to a concert but not going to the show. While writing this book, I sought out people who consciously inked with deep intention and purpose. There seemed to be a common theme: many of them said they had more lucid dreams after getting tattooed. Another commonality was that during their tattoo session, there was a feeling of drifting into a Zen-type state. Some even said they felt an overwhelming purge of emotion.

Dan Benonis is a music therapist. He shared with me an interesting story about two tattoos he had inked. He decided he wanted the tattoos underneath each one of his arms. Dan said:

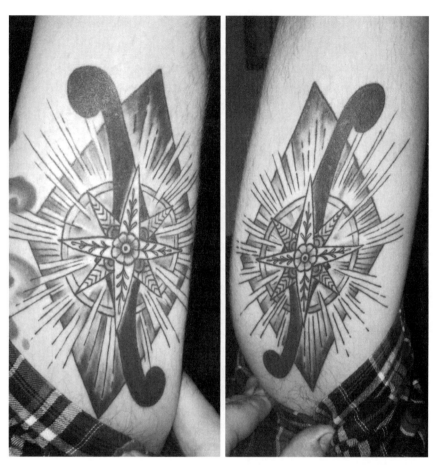

Tattoo by Patricia "Miss Trish" Sanchez Cunningham.

When I first had the idea for these tattoos, I wanted to get two F-holes underneath each one of my arms. When people hear *F-hole*, they immediately think of something dirty, but the F-hole is a portal in an instrument that resonates the sound. Think of a violin, cello, or semi-hollow guitar. The slot that you see in the side is an F-hole.

As I readied myself to get this tattoo, I had a dream. This dream told me that I needed a compass. In the dream, I had the lines and measurements of a

compass tattooed on me. I decided that I should have a compass rose on top of an F-hole, and have it inked on each arm. To me it is a representation of resonating on a higher level in my life. After I got the tattoos, I began suffering panic attacks that I believe were a release of negative energy and a pathway to my next chapter for my soul.

Dan told me this wasn't his first experience getting a tattoo. He was shocked by the emotional shift and the panic attacks brought on by these two F-hole tattoos. The piercing of the skin most likely incited and shifted some emotional energy held in his subconscious. The tattoo itself is a portal, and he chose to put the image of an instrument's portal on his skin. This was, in the sense of energy, like putting a portal on a portal, making his tattoos even more receptive to being an outlet. I told Dan it most likely was a release of fear-based emotions, maybe from a past life when he got caught for hiding, either himself or something else. In any case, this experience offers Dan the opportunity to explore his consciousness and find the hidden story.

Ancient cultures practicing shamanic tattooing actually laid the groundwork for our modern exploration of consciousness. The tattooist who is inking your skin is, in a sense, the shaman who is facilitating your journey into the layers of your psyche. They help you depict and translate, through art, the voice of your inner muses. Most tattooists will not ink an original tattoo on someone other than the person for whom it was created. You may like someone's unique tattoo, but it depicts *their* consciousness, not yours. By threading ancient tattoo practices together with our advanced concepts of consciousness, we can delve into the deeper layers of ourselves.

Tattoo medicine for transformation

Tattoo medicine (spiritual healing tattoo) is fast becoming the new buzzword for spiritual-seeking neophytes who have moved on from traditional religious dogma and hours of psychotherapy. Tattoo medicine is a tattoo that represents a return to wholeness, a shift into a new wave of consciousness that encourages authenticity, diversity, and presence. It is a process that may involve some life coaching, a form of divination (tarot or astrology), and a waiting period before you are ready to get your tattoo. This is becoming a sought-after inner healing modality.

Mindful tattooing is also a commitment to deep soul work, to making what is unconscious conscious and finding your medicine. This means you look inside yourself, not outside, in order to find the parts you buried away when you were hurt or experienced some sort of trauma. Acknowledging the pain, then releasing the emotional energy, is what heals you. Your tattoo medicine is a physical symbol that holds space for that healing. It's a tattoo you intuitively know where to ink on your body. Most likely, it will wind up being the muscle area or chakra area that was holding the unreleased emotional pain.

This process may take time because self-revelation can be intense. It forces you to walk out of your comfort zone. The end result is a tattoo that helps you feel more whole, more real, more authentic, and more *you*. It represents an unshakeable alliance with your inner wisdom and your inner healer. Scoring a tattooist who fits this need is like finding the Dalai Lama of ink. A more spiritual tattooist takes the time to establish an intuitive bond with you so they can co-create a meaningful tattoo suitable for healing. The connection must be right because they are working closely with your spirit in order to create your tattoo medicine.

A lot of spiritual tattooists are also healers who do body work, such as Reiki or massage. They may also provide a little bit of

shamanic soul journeying if they need to go into one of your dreams in order to heal any emotional wounds and trauma. This is *definitely* not your father's tattoo parlor with old school flash art hung on the wall. Spiritual tattooing is to initiate a deep inner awakening for transformation.

Of course, the psychology field would say you are just imagining a change happened because you got a tattoo. Regular MDs will just stare at you and probably send you back to the psychologist. The Western tenet of medicine still believes that the body is one thing, the mind is yet another, and the spirit resides in some house of worship. They fail to accept that we are just one system and every layer feels the effect of tattoo medicine.

There seems to be a resurgence in mindful tattooing, along with a shifting awareness that this is a sacred art. Through a series of synchronistic events, I came upon Victoria Wikler, who is a transpersonal practitioner and birth doula. She is an autonomous truth-seeker, who tattoos with integrity and compassion. Her tattoos support self-healing and a return to wholeness, helping to recover the essential parts of ourselves that have been damaged, hidden, or lost.

Victoria is a young woman with an old soul who has a fascinating story behind her own spiritual journey. She left college and a scholarship behind in the United States, and moved to Ireland where she became part of a Celtic women's group. Her initiation into the group was very intense. She went deep into nature and into the self. She symbolically experienced death by literally digging her own grave. Her allegorical death gave significant meaning to relinquishing the ego in order to gain access to the Otherworld, the realm of spirit, beyond ordinary time and space. Her intimate connection to the spirit realm enabled her to retrieve healing, guidance, and vision. Her tattoo work is highly reflective of embodying both mystical health and an interpersonal birth celebration for her clients.

Here's what a typical session with Victoria involves: "I offer intuitive designs, and imprint ceremonies that are split into two days, one for a shamanic consultation, and the other for the tattoo treatment." Victoria elaborated on the two-day process:

> You come to my studio in the late morning or whenever works for you. I live/work in Bucks County, PA, an area that seems to have a sense of its own mysticism. I ask my clients to eat breakfast and take some time to themselves before getting here. I provide a nutritious, highly vibrational lunch, snacks, and tea and we start with an in-depth tarot reading, not so much about the distant future, more about your deep present and past, navigating through to the near future. Based on what we uncover we decide where you'd like to go deeper. When a decision is made to go further, I then conduct a guided shamanic journey to that place and slowly leave you to explore what is there and possibly still affecting you in this life.

Victoria explained the shamanic journey session is guided by her voice and the sound of a drum: "You can expect tears, and laughter, as you go through the process of self-revelation. The shamanic journeying assists in uncovering the client's birth rite. This is a pretty intense exploration of what's no longer serving you in the present, and how you can use your birth-given gifts to get you to your future's best outcome."

When the journey is complete, Victoria has her clients draw or write about the experience before they discuss it in-depth, as to not leave anything open. The spiritual sessions typically last about two hours, but can take as long as it's necessary. "Sometimes clients, and myself, see symbols and images that are really important," Victoria said. "They may then choose to receive a medicinal tattoo from me in another session."

As for the actual tattooing process, Victoria explained:

> The tattoo treatment consists of an oil massage on the spot that holds the most tension pertaining to your spiritual theme, and then we tattoo the design on that spot. The design is made straight from your experience and journey so there is no telling what it will look like or where it will go until the session is over. This is an important step because traditionally, in tattoo medicine, it is deeply understood that scars and opening of the skin in this way allows free flow of healing into the body and lets toxic and old energy out.

How long does the actual inking take? Victoria told me it can take anywhere from 90 minutes to five hours. Her goal is to make the client feel happy about celebrating themselves.

I wondered if people came to Victoria with an explicit tattoo. She said, "Of course if they have any reference, or suggestions, they are welcome to send them my way, but there is no guarantee that they'll receive the exact design because the initial design usually expands after our sessions together."

Regarding concerns over the toxins and metals in some inks, Victoria explained:

> Yes, that is why I make personalized medicinal ink and tattoo with a sterilized tattoo needle by hand, not with a machine. All of my tattoo products are handmade and have medicinal qualities. Black ink is made with activated charcoal, reishi, and chaga mushroom extracts. Colored ones are made with an array of medicinal herbs including turmeric, beets, blue-green algae, ashwaganda root, calendula, and many others.

Victoria said her tattoos are mostly intuitively drawn symbols and the application is hand-poked, meaning no tattoo machine is used. This method of using a needle attached to a stick is also referred to as "stick 'n' poke." This is a very natural and organic process for those looking for a more authentic, spiritual tattooing experience.

I asked Victoria if she had any thoughts about traditional tattooing and colorful images, some of which can be very dark. She explained, "I personally see tattooing as a sacred ceremony, especially since it is one of the oldest traditions rooted in mysticism, spirituality, and magic. As far as disturbing images inked onto the skin, I just feel that some people like to wear their shadow and find a lot of comfort in staying in a lower vibration."

Victoria feels tattooing is a very personal form of self-expression and she made a good point when she said, "Even *silly* tattoos have a lot of meaning because they show that the person wearing that type of ink is someone who wants to project their carefree side, and show how they care for people by making them laugh."

Victoria's tattoos are very organic and beautiful. They are representative of inner healing and celebrating yourself for being you.

Victoria explained how her back tattoos brought her to a new path:

> I am the woman near the tree and those back tattoos started my whole journey. I dreamt of those symbols which turned out to be in an ancient Irish language that I'd never seen, and then found that they actually say *mystic* and *pilgrim*. So, I had them tattooed on me with the same method that I use now, way before I even started tattooing. Masculine symbols on the feminine side of my body and feminine on the masculine side.

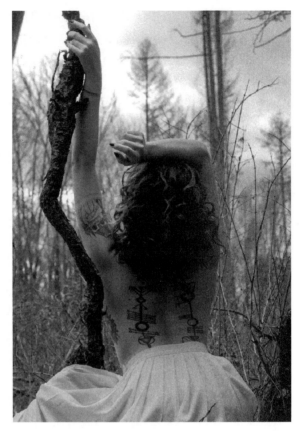

Tattoo by Roguepokes. Photo by Matt Kelly.

Tattoos and body frequency

Let's open the door a little wider and look at tattoos from the eye of energy medicine, usually regarded as vibrational healing or vibrational therapy. This is a healing philosophy with a main tenet that declares humans are dynamic energy systems (body, mind, and spirit complexes), and your frequency reflects the state of your being. The idea in vibrational healing is to find resonance for inner and outer harmony.

To start, everything is vibration, from the chair you may be sitting on to this book you are reading. Yes, even your tattoo is in a state of vibration. This is not a new idea. Ancient mystics have known this wisdom for many millennia. Some of the modalities used for

vibrational healing include color, light, sound, chanting, flower essences, acupuncture, chakra balancing, essential oils, Reiki, and crystals. They all introduce a vibration into your energy field. They also enter the world of your subtle energies and bridge into the domain of your deepest spiritual contents. It is relevant to know that the frequency from a tattoo will shift your energy. This is something that's often overlooked.

Tattoos can be considered a permanent frequency patch. You embody the colors, design, intention, and placement, all of which interface with your body's vibration. No matter where you are inked on the body, tattoos will be near either a major or minor chakra. Tattoos are holding a vibration that goes into you both physically and spiritually. They can continue to stimulate an energy in your subtle energy field long after they have been inked.

Tattoos have a built-in charge consisting of intention, emotion, symbol, and color. They go deeper than other vibrational therapies used, like healing crystals, color therapy, essential oils, or flower essences that you apply and then put away. Tibetans tattooed mantra wheels on the chakras to foster spiritual and physical health. This was done mindfully and with great respect for the hidden power in the tattoos, which act as an applied vibration into the body.

Tattoos that you get with a defined intention, for spiritual and self-healing purposes, will have a higher vibration. This is one of the reasons you should consciously decide what you are inking and why you want it. The tattoo's energy is going to continue to filter through and either work as a spiritual healing or hindrance. A healthy body typically has a range of 62 to 78 MHz, with disease beginning at 58 MHz. Everything—the food you eat, the thoughts you think, and the ink you have on your body—has a direct effect on your frequency. For example, a positive mental attitude, prayer, or meditation can raise it by 10 to 15 MHz. Just holding a cup of coffee can *lower* your body frequency by about 8 Hz. Imagine what a tattoo can do. Crazy

stuff, isn't it? You probably didn't consider these things before you got inked (or had that cup of coffee this morning).

Chakra centers handle and process your body's electromagnetic energy. They also serve as vortexes for the flow of energy from the physical to the subtle bodies (emotional, mental, and etheric). Before you get tattooed, you can do a quick version of muscle testing, which is a way to see if something is in resonance with your frequency. Hold a picture of the tattoo image in your hands and pull it in close to the solar plexus chakra (gut). Stand with both feet slightly apart and see how you sway. Your body will send a sensation to you so you will intuitively know how to feel a *yes* or *no* answer. A *yes* will shift you forward and a *no* will shift you backward. If you don't have an actual drawing, then you can strongly envision the tattoo in your mind's eye. This, too, will produce a feeling that will let you know if the tattoo is the right frequency for your body. If you are familiar with using a pendulum, you can also use it to see if the tattoo is right for you.

There is a lot to consider because even if the image or symbol resonates with you, the color and metal elements in the ink may not be compatible with your system. A tattoo that is out of tune with your body's frequency may even result in a feeling of depression. It can keep a certain area of your body locked in a vibration that causes problems. Moreover, heavy metals are often present in colored inks. They can contain lead, cadmium, chromium, nickel, and titanium. Red ink may be the most difficult on your frequency because it contains mercury sulfide. These metals can throw your frequency off, so it is a good idea to mindfully maintain your tattoo because it is an energy portal. You can work with vibrational modalities to bring it into a better resonance with your electromagnetic field. Resonance occurs when the first object is vibrating at the natural frequency of the second object.

While writing this book, I wondered if there were any tattooists who took vibration and resonance into consideration when tattooing a client. I asked Spirit to help me find someone who

understands body resonance and who also practices the symbolic, expressive, mystical, healing, and transformative aspects of tattooing. Through intention and spiritual intervention, I was led to Daemon Rowanchilde, a transpersonal tattoo artist, psychospiritual explorer, and owner of Urban Primitive Tattoo Wilderness Retreat in Monteagle Valley, Hastings Highlands, ON, Canada.

Daemon is an artist who is well known for his body art. He calls his approach to tattooing the "Art of Transformation" and incorporates skills from yoga, sound vibration healing, Source Energy Medicine, and Reconnective Healing into his sessions. He uses tattoo art primarily as a spiritual tool to facilitate access to inner resources for healing and transformation. Every one of Daemon's designs is a personal emblem or soul print of an individual's inner magnificence.

Because his method of tattooing is relevant to this book, I called Daemon to ask about his process. Daemon explained:

> I tattoo with an awareness of the spiritual dimensions of permanent body designs and its potential to affect the human energy field. I see parallels between my role as a tattoo artist and that of a spiritual midwife. I specialize in tattoos inspired by tribal societies with patterns reflecting the art of diverse sacred shamanistic cultures and geometry found in nature."

Daemon has also inked a number of tattoos using an old tapping technique that was practiced before the invention of the electric tattooing gun:

> I explored the tapping technique with my tattoo machine and found that this technique is easier on the skin, less painful, and led to faster healing. It also allows both the artist and the clients to easily enter the "zone" or "flow zone" experience—a euphoric feeling of presence and timelessness—and to stay there for most of the session.

Regarding the link between spirituality and tattooing, Daemon said, "I believe that tattooing is a spiritually active process helping to facilitate the unique expressions of various energies and healing in very meaningful ways. This is why I feel honored to serve the needs of my clients, the living portals of these energies, in all aspects of their tattoo experience."

I was intrigued and wanted to know about the complete tattoo experience. Daemon explained:

> My approach to tattooing includes a full-immersion nature retreat for our tattoo clients. This experience ranges from a farm stay, hiking in the wilderness, to sweat lodges and ceremonies led by Anishnabe elders and healers. At Urban Primitive, my studio is a sacred space. My wife Raven and I provide comfortable overnight accommodations, prepare nutritious foods, and implement healing modalities, such as Source Energy Medicine, which we incorporate into the water we serve and cook with. We also charge the tattoo inks with Source Energy and offer the option for Reconnective Healing at the end of tattoo sessions. Reconnective Healing facilitates faster healing of the client's tattoo along with other deeper healing benefits.

What does a Reconnective Healing practitioner do after a tattoo session? Daemon elaborated, "The practitioner doesn't *do* anything because there is no technique. The practitioner works entirely hands off in the field surrounding the client's body. Through awareness and perception of a new spectrum of healing, the practitioner is able to resonate and interact with frequencies of energy, light, and information, and thereby entrain the client's energy field to rise to a new level and resonate with these higher frequencies."

Daemon noted that these frequencies:

Act on meridians, chakras, electromagnetic fields, and the light body to return a person to a state of balance and wholeness. The practitioner, therefore, also serves as witness to a client's return to wholeness. The reconnection helps us remember that we are multidimensional beings of light and reconnects and realigns our light body with the boundless field of infinite possibilities. I am committed to providing clients with full support and nourishment during their entire tattoo process.

One of Daemon's clients, Amanda MacDonald, shared her tattoo story. Amanda received an incredible healing from her tattoo, which helped to bring the resonance of her body back to wholeness. Below is the account of Amanda's experience, in her own words:

In the spring of 2013, at age 42, I was diagnosed with breast cancer. My world stopped. I was diagnosed with invasive ductal carcinoma. I was fortunate that all I ended up needing to cure my cancer was a mastectomy. I had caught it early enough, thanks to strange fates prodding me and listening to my intuition.

The reconstruction process took four surgeries, but every one of them was a positive experience. I was being transformed back into me. Except, there was one location on the armpit side of my reconstruction which had always been sore since day one. It would ache, with a kind of soreness that felt more like sadness than pain. I would put a heat pack on it and hold myself to calm it but it was always there.

Through an amazing client, I found Daemon at Urban Primitive. I explained my story and was blessed that he accepted me as a client. We planned a lovely huge tattoo which would celebrate my return to "normal" appearance and give some beauty back

to my body that had sacrificed so much for my survival. I was so excited for the end result.

What I didn't realize is the transformative power of the act of being tattooed. Daemon explained this to me, and I was skeptical. I'm a scientist, medically trained. I thought his philosophies were interesting but probably not going to affect me. The first day we created a beautiful vision for the tattoo and began the tattooing. I won't lie; it hurt. After several hours, I wasn't sure I could keep sustaining the burning feeling. Then we reached the sore spot. As he tattooed over it, I felt immense relief and discharge, and it felt good, like finally being able to touch something that's been out of reach. I would have tattooed a big dark spot right there to keep this feeling. That night, I awoke several times, always to the same vision. The sore spot where I had been tattooed had opened up, and a sinewy black smoke was slipping out. As I breathed, it would pull more of itself out, like a quiet demon leaving. Over and over, I had this vision. When I awoke, the soreness was gone. And it has not returned.

I love my tattoo, as I expected to, but it is now not the end point in itself; it is the reminder of the healing gift I got being tattooed. It marks the delineation between having cancer happen to me and having had cancer. The disease is gone, the pain is gone, and I finally got to lay that burden down. There is no denying the profound effects of tattoos.

The multidimensional, vibrational aspects of tattoos are often qualities that get overlooked by people who only choose to realize tattoos solely from the visual aspect. Beyond what we see, there is also a mystical vibration that swirls around body art.

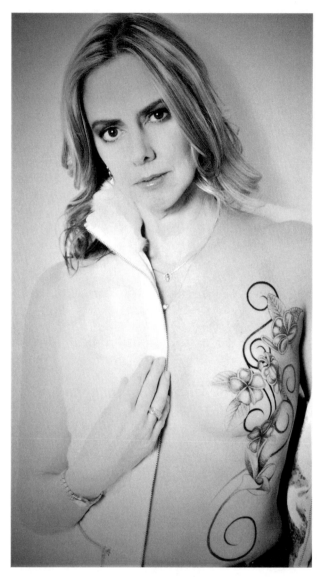

Tattoo by Daemon Rowanchilde.
Photo by Laurie Cadman.

MYSTERIOUS PORTALS TO OTHERWORLDS

There is something deep, profound, and boundless about tattoos and being tattooed. Getting a tattoo not only opens portals on your skin, but also exposes the mysterious realms of consciousness. The act of inking itself produces highly charged energy that can whip your chakras, especially the three lower ones (the physical world), into orbit. The fear, needles piercing the skin, blood, and rush of endorphins are the precept for a highly charged transcendent experience. Tattooing can bring about an expanded awareness that takes you well out of the somatic norm.

Most of us have to admit we have a secret appetite for experiencing altered states of consciousness. Sometimes the closest we get to having one is when we dream and traverse the membrane between time and space. For some people, getting a tattoo can feel like a mini shamanic journey to the otherworlds. The physical process opens the pathways to the spiritual centers. Your chakras shift gears, and the body sensations produce higher energy that can incite the higher functions of the chakras to bring about enhanced awareness, such as the psychic-sensing qualities of each chakra center.

It is possible to find yourself in an altered spiritual state while getting a tattoo. The pain from piercing the skin changes your breathing pattern, and sitting for an extended period of time shifts your awareness into another realm. For some, sliding into another zone of consciousness is a way to disassociate yourself from the fear and pain that can accompany getting tattooed. Some people describe this as an out-of-body sensation or even as an embodiment of a spiritual energy. It's a weird, mystical experience that is hard to describe. A combination of fear, pain, and endorphins followed by an inner shift of stimulated emotional energy are passports for a wild trip.

Nearly all indigenous people who tattooed for spiritual and magical purposes also practiced shamanism, which is the more benevolent but equally powerful use of magic and mysticism. It has been

established by archeologists that many of the indigenous cultures that tattooed had strong beliefs in the world of spirit. You might say the mystical is hard-wired into the DNA of tattoos.

Tattooing was, and still is, a sacred art filled with mysticism. There are monks in Tibet who make magic ink for the tattoos they administer. This is to keep the wearer of the tattoo humble. The magic ink will make them feel like they are always in the presence of a monk. Today, when most people go to get inked, there is still the allure of mysticism that clicks with our spiritual awareness to connect the known with the unknown. The whole process, from image to ink, pulls us into a ritual that reeks of otherworldly phenomena. Through your ink, you have immortalized and embodied an image that has deep connection to something that touches your spirit. You walk away feeling transformed and even empowered.

There is an occult, or hidden, energy within your tattoo. The symbols you ink onto your body are metaphors showing the transference of power from the consciousness to the physical. You embody the influence of your intended creation. Just thinking about the art you wear can incite the flow of energy in your tattoo portal. Having an awareness of your inner source of power is what allows you to experience, and realize, the extraordinary, the magical, and the mystical.

Tattoos are naturally mysterious. Only the wearer of the tattoo, and possibly the tattooist, know the backstory or hidden meaning that may be shrouded in the cryptic symbols and patterns. Pay attention to the experiences you have after you get a tattoo. You may have strong emotions, conjure lucid dreams, or experience synchronicity and other phenomena. Stimulating energy in the subtle bodies leads to an unfolding of the unknown. Your ink just shifted something around in your consciousness. The images you ink on make you ask, "What is my truth? What is the veiled knowledge?" The hidden is awakened.

The heightened awareness that comes with getting a tattoo, from the pain to empowerment, can alter the frequency held within your electromagnetic field, aura, and subtle bodies. Don't be surprised if you suddenly begin to have an awakening of your psychic and intuitive abilities. When your body is at a higher vibration, psychic sensing and keen intuition occur. Additionally, many inner archetypes and shadows can be brought into three-dimensional reality, manifested as your tattoo.

I had a conversation with Alex March, a Reiki master, empath, and psychic medium who is aware of the mystical qualities woven into tattoos. Alex, who is a former tattooist herself, incorporates her tattoos into translating the perceptive voice of spirit so she can help others receive the messages and guidance they need to hear from the other side. She sees her tattoos as energy portals, sacred spaces on her body that aid her in assisting others during a healing session. Alex was willing to share her personal experience of integrating tattoos into her journey of healing, self-revelation, and helping others:

> Tattoos have always been incorporated along my journey. I started apprenticing as a tattoo artist in 2008. While tattooing, the mysticism of this sacred art began to unfold for me. I could psychically sense what others were thinking, physically feel their pains, and even pick up on the dead who would come through my body to deliver messages. Spirits were drawn to me. I hadn't realized my gifts were attracting people, and through my good tattoo ritual, I was sending healing their way by the images I tattooed on them. My energetic intent helped clear past-life incarnations, childhood traumas, and karmic wounds that were still existing in their cellular memory.

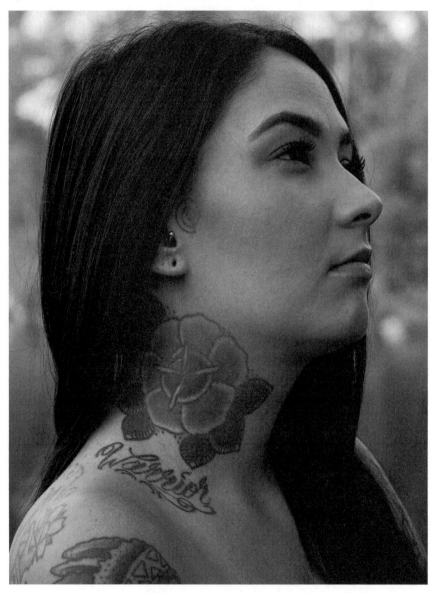

"Warrior" tattoo by Ian Griffith. Photograph by Kara Donnelly.

During her awakening journey, Alex entered a relationship with another tattooist:

> [We] stepped into the whirlwind experience of traveling the country and tattooing together. We got engaged, and I had a tattoo inked on my ring finger with the letters *A* and *O* which stood for *alpha* and *omega*, first and last, because I believed this was who I would marry.

Alex's former fiancé asked to tattoo her neck, and because she wanted one of his signature roses, she agreed. However, Alex recalled:

> I didn't want it as big as he made it but I guess I had to just let it happen. He was an intense person and his intensity was imbued into the tattoo. It was the most painful tattoo of my entire life and took long to heal. Our relationship eventually ended but it left me with great insight into my own healing.

Did Alex regret the rose tattoo? "In retrospect, I know the rose tattoo didn't heal well because it was his energy in my cellular memory," Alex explained. "Upon looking at the tattoos on me, I sensed and realized that the giant red signature rose he inked on my neck was related to a past life. I was strangled in a prior life, and my soul remembers the trauma. My intuitive need for tattoos on my neck showed me and protected me until I remembered my past so I could heal it."

Ultimately, Alex realized she needed to shift the energy of the tattoos from her ex and get him out of her body:

> Since the tattoos he inked on me weren't coverable, I added the word "warrior," and took my power back and made them my own. "Warrior" is now my battle song. It reminds me every day how I can get through

anything. The word "divine" is also tattooed on my neck, and it is the embodiment of the divine energy protecting my throat, not knowing if I was potentially going to be murdered again in this life.

Alex continued to do psychic medium readings after traveling the country applying tattoos. In that time, her psychic gifts had accelerated. "I use my empathic body and tattoos to give me validation during a reading," Alex said. Regarding how her ink helps her as a medium, she states:

The tattoo on my ring finger that made me feel unlovable became a valuable tool when reading others. Rubbing my ring finger during a healing session is an empathic signal that someone experienced an abusive relationship. Every tattoo on my body has become a message for someone during my readings. I realized my true path as a medium and empath through the transmutation of my tattoos. They are portals on my body that help to bring fourth the mystical nature of spirit.

There is no doubt about the mystical qualities held within the sacred, spiritual modality of tattooing. When you get a tattoo, you are embodying the meaning you give to the symbol. Symbols, in themselves, exude a cryptic sort of message that registers within our consciousness. As a matter of fact, mystic symbols were popular in the ancient tattoo tradition because they would grant certain qualities. If you needed the strength of an animal, wisdom, or good fortune, it could be poured forth into you by the magic in the tattoo. Art holds both a magical and mystical quality and, in all its variable forms, is often indistinguishable from magic and mysticism. All three share the commonality of penetrating into the realms of consciousness, your intimate space.

So, what's the difference between magic and mysticism? Magic is a derivative of mysticism. There is a marked difference in seeing tattoos as either magical or mystical. The fundamental difference between the two is this: magic wants to *get* something, and mysticism wants to *deliver* something. A tattoo you get for the purpose of conjuring something specific is considered magic; an example is if you tattoo a certain image to deliberately embody a precise magic symbol so you can intentionally draw from the power of the image. For example, a tattoo of the athame/dagger may be an image used to channel and direct psychic energy, which gains the practitioner strength and power, and aids them in manifesting what they will.

Some people may want to get the same tattoo image because they like it, but not to decisively use it for magical work. Their athame/dagger tattoo is more symbolic for the embodiment of purpose and ambition in a natural way that unfolds as needed, not directed. Consciously forming an intention for your ink determines how the hidden esoteric energy is realized. They differ enormously.

The magic in tattoos

Tattoos are also portals into the realms of magic (or *magick*, in esoteric writings). There are some people who get tattoos strictly for magical purposes. Magic is not necessarily dark. It is more connected to intentionally manipulating and directing energy in order to achieve a specific outcome. Tattoos associated with magic are inked with the intention of making them portals that can be opened and closed at will. They provide a consecrated space on the body so the wearer can ask for specific energy to flow through for empowerment. There is an impassioned desire to achieve a specific outcome by calling upon certain spirits and deities. Sometimes the tattoo image will be a magical symbol or deity, so the wearer can intensely embody the energy for magical purposes.

There is a caveat when dealing with magic. Energy you purposely form and direct with strongly focused intention will entrain with other energy to form a resonance. If your purpose for magic is for a higher good, then what you attract back to you should be beneficial. The opposite is true if you send out dark forces. Remember, you are the generator of the energy so what goes out into the ether waves also entrains with your energy. This is why some tattoos are a source of bad juju.

By this point, you may be thinking that you just wanted a freakin' tattoo. What is all this mystical, magical stuff? Does it hold influence in the tattoo if you don't believe in it? That is like asking if your dreams hold inner meaning even if you don't believe in dream interpretation. Tattooing is a sacred art that is also mysterious. The elements of the esoteric are woven into tattooing. When you get inked, you entangle a lot of emotional energy. It comes in, it goes out, it shifts around inside your consciousness. Either consciously or unconsciously, your spirit is awakened by getting a tattoo.

There is hidden magic in some symbols. It's possible to have a bad emotional reaction to a tattoo if you are not familiar with the meaning of certain esoteric images. Granted, in most cases you determine what a symbol personally means to you, but there are ancient magic symbols that don't have flexibility to be other than what they are. There are symbols that hold very strong energy vibrations, and in the scope of magic, these symbols are sacred and invoke spirits.

The esoteric meaning of some symbols can be pretty scary. An example would be the sigils—inscribed symbols considered to have magical powers—from the Lesser Key of Solomon. They are used for summoning demons for earthly desires. You could have inked a symbol, mysterious or otherwise, that isn't right for you. The symbol

can adversely affect the frequency of your subtle bodies and possibly trigger something in your deep consciousness from a past incarnation. Even if you don't believe in tattoo "woo woo," it is still an ever-present part of the image.

We shouldn't think of the esoteric or occult as belonging only to ancient cultures. Today the philosophies of our root belief systems are kept alive in subcultures like Wicca, neo-paganism, Celtic Druids, and other nonconformist groups of authenticity and diversity. These underground subcultures and their esoteric approach to life have rolled out an organic new belief system popular with the masses. Suddenly people identify with being spiritual over religious, and tattoos seem to be the new spiritual adornments.

Looking at tattoos from the esoteric perspective gives you yet another facet of this sublime, sacred art. Tattoos entice you to look beyond the veil and cross the threshold beyond ordinary reality. Whether you choose to view tattoos as magic, mystical, or spiritual determines how you will integrate that belief into your consciousness.

There are some people who are afraid of the M-words. Those who want to tiptoe into the otherworlds prefer to think of magic or mysticism as creative visualization and the law of attraction. They are one in the same, only realized differently.

Tattoos as body talismans

There are some people who tattoo with the firm intention of wearing a body talisman. It is usually an image or symbol that is purposely inked on to act as a portal for your desired intention. Talismans are usually for good luck and protection.

Talisman tattoos are becoming very popular, but if you really want to feel your mystic vibe, it should be done precisely for what you want. Talisman tattoos are often used as transmitters, projectors, or

attractors. Determine the tattoo's purpose. Will it be used for deep soul healing? Protection? This is a permanent tattoo talisman, so really give it some thought.

A talisman tattoo should be created by the person who plans to use it. No flash art is allowed. Ideally, tattooists inking the talisman should be familiar with all of the different planetary and elemental forces, along with the symbolism connected to making the talisman.

If you want a talisman tattoo, as opposed to just a good luck charm tattoo, then I recommend researching talismans. Some of the symbols are pure alchemy. Also, when inking a talisman, it is best to do it according to certain phases of the moon and planetary influences. The tattoo that is acting as a talisman should be inked in accordance to the placement of the planets. This will line up the cosmic energies with the intention imbued into your tattoo.

If getting into the esoteric process for creating a talisman tattoo is a little heavy for you, then consider something a little less complicated. Many people have a standard good-luck tattoo. This is ink that you see as holding space on your body and acting as a portal for the positive. It can be any image that expresses good fortune. Many people ink a four-leaf clover or a horseshoe, among other common symbols associated with luck.

Does it work? It works if you consciously keep an open connection to it. Awareness creates the reality we choose to experience. Your thoughts frame your tattoo. Your tattoo frames your thoughts. In any type of magic, desire and intention are the creative forces for actualization.

~

There are some people who are just naturally fascinating and Bryan Rawls is one of them. Bryan is a certified psychic medium, Reiki master, light language channel, and a Wiccan Level 2 High Priest. He also has tattoos he considers to be his highly charged talismans. I asked Bryan how he became interested in the esoteric arts. "Since about the age of 7, I have been able to see beyond the veil into the world of spirit. I realized that I could also feel people's moods," he said. According to Bryan's grandmother and aunt, his family heritage is "a lineage dating back to the 1400s. I come from a long line of Wiccan healers. With great patience, they began to teach me more about honing the abilities of our bloodline."

On how he came to choose the tattoos he considers talismans, Bryan said:

> First I had a dream about the symbol that I was supposed to have tattooed on me. It was to be a branding by the Goddess. After I got the tattoo, I felt an instantaneous difference. I found that when I do Reiki, I am told where to place my hands for precision type of energy. I also found that I was given an understanding of ancient glyphs and symbols. This tattoo has been extremely self-empowering for me.

One of Bryan's tattoos is a Blue Goddess symbol, which he says speaks directly to his ancestral lineage:

> I have been bestowed great wisdom and magic through symbols. It traditionally signifies the Goddess energy, the divine feminine. This tattoo initially started working directly on my subconscious before I even thought about putting it on my skin. The day I went to go get the tattoo, I began to hear the Goddess loud and clear. Before I got the tattoo, her communication with me was faint and muffled.

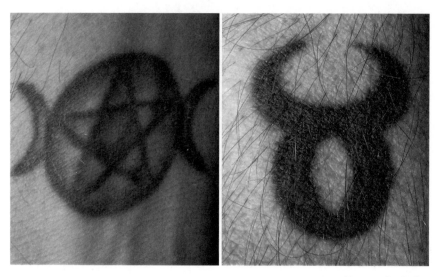

Tattoos by Baby.

Since the tattoo, the communication has stayed very audible. These tattoos are important when I do magic and ceremony. I intentionally open these tattoo portals when I want to fully embody the Goddess and the Goddess intuition.

Regarding his God symbol tattoo, Bryan said it:

Speaks one of two things to me, which is my zodiac sign, Taurus, and also signifies the God energy divine masculine. This has allowed me to understand and accept my sexuality and really has allowed me to dive deep into the psyche of the male body. It also has really gotten me in touch with many masculine and androgynous beings such as Pan, Poseidon, and Apollo.

Opening the portals for attachments

Tattoos certainly transcend the ordinary. They not only open the door into the realms of consciousness, but they also open a portal into your subtle body energy field. The piercing of the skin with needles tears your aura, and this leaves you vulnerable to picking up unwanted energy attachments.

The tattoo ritual is in itself a blood ceremony. Blood that is drawn in the sense of ritual attracts entities that are attracted to the high energy of the blood, the life force energy. Remember, tattooing is a sacred art, as in spiritual or dealing with spirits. If you are not cognizant of your surroundings and you are getting inked in a busy shop that has lots of emotional energy flying around, you may easily pick up an energy attachment.

You and the tattooist are energetically corded to each other during the tattoo session, and this energy cord can also remain as an attachment. It's an extension of your energy, connecting to the energy of the tattooist. Because the tattooing process is opening a portal in the aura, their energy is also invited in, possibly as an unwelcomed guest. The artist may have a strong emotional energy attached to the art they are creating, and this energy is imbued into the tattoo. You're going to permanently wear it.

Some tattooists will refuse to ink certain images because they don't want to be attached to the bad vibes they get from the art. Some art can be eerily dark. They may also refuse to ink people who are demanding or have a bad attitude, as tattooists won't want to share or cord into that person's energy. Artists who still ascribe to the original ancient beliefs that tattooing is a spiritual art also know it is a magic art.

Thoughts, feelings, and interactions between yourself and another person, place, or event are the way energy attachments form. Typically, by and large, cords exist between two individuals: one

as the sender of energy, and the other as the receiver of energy. Tattooing is the perfect storm for creating energy attachments. It incites emotional energy held in the body, it opens a bloody portal, and it has the elements of creation from the art to the inking.

Emotions have an energy value from cool to hot. The electrical charge entrains with surrounding residual energy and pulls it into orbit. Your chakras filter the energy, but some gets stuck in your subtle body system and causes blockages. This attached energy attracts similar energy that can compromise your vibration. Body workers especially come into contact with people who have taken on attached energy. They work with the client to move the energy and clear the space where it is held in their body. Many energy-sensitive body workers can feel a shift or different quality of energy around tattoo portals.

Attachments can also come about when a tattoo is used specifically for conjuring. Unless you are well-versed in the protocol for magic ceremony, this is not suggested. You already embody the intention, image, and emotion of the tattoo, so calling forth a deity to enter into your electromagnetic field for magical purposes can leave you wide open for an attachment that can control you, instead of you controlling it. Magic is no joke. Ancient scribes who wrote about magic considered it to be a high art for creating, conjuring, and materializing.

It's easy to say, "I don't believe in that stuff," but that could be because you never considered the depth of tattooing. In an esoteric sense, your ink may link you into something that energetically attaches to you. A tattoo may carry a very strong energy attachment, possibly due to your own emotions attracting outside energy or from the tattooist who put a lot of emotion into creating the tattoo. Tattoos are, in a sense, magnetized portals, and account for a high amount of apparent energy attachments. By the way, this affirms that you

should be of a clear mind and good conscience before you get a tattoo. In other words, don't drink and ink.

Also, consciously choose where you go to get inked and who will be doing the tattoo. To give an example, tattoos applied in a holistic manner are going to have a different magnetized energy than tattoos applied in prison. The residual energy lingering in the tattoo environment will make its way into the open portal on your aura.

The image you ink is conceived in your imagination and then through the intimate process of tattooing. You, along with the tattooist, have created a magnetized picture on your skin that filters throughout every layer of your subtle bodies and becomes a realized part of you. Metaphorically, it is the sperm and the egg creating a viable new life.

Many tattoo artists and other creatives, such as film makers, authors, musicians, and writers, will tell you how the imagination develops a life of its own and steps into materialized reality through the arts. Tattooing is an art, a sacred spiritual art, and unlike the art you hang on a wall, tattoo images on your body live along with you. They are active energy attractors because of their magnetized quality. Tattoos attract stares and attention from other people. In a weird sense, they are calling cards for outside energy. This means outside energy can entangle with your energy field.

Okay, so how do you know if you may have taken on an energy attachment? Attachments are spawned from emotional energy that goes rogue. When we take on another's emotional energy or an attachment from a place, we typically react to this intrusion subconsciously. We experience this unwanted energy as a part of ourselves instead of recognizing it as being an invader.

After getting a tattoo, see how you feel in the following weeks. Aside from processing some emotional stuff from your own

consciousness, if you at any time have a feeling of being controlled or manipulated, then you may have a negative attachment. All attachments are parasites. Their vibration is low. The vast majority of people with energy attachments may be unaware of their presence and feel as though their life is out of control. Here are a few things that indicate you may have picked up an attachment through your tattoo portal:

- Feeling ungrounded.

- Memory problems.

- Hearing weird messages in your head.

- Repeating patterns of behaviors.

- Anxiety or panic attacks.

- Irrational bouts of fear, anger, sadness, or guilt.

- Sudden changes in behavior or mood swings.

- Change in sleep patterns.

If you think you may have an attachment due to getting a tattoo, pay attention to the area that was inked. Feel around your aura. Do you sense some heat or tingling in and around the tattoo area? Do you feel a subtle pressure on your skin, as if someone is standing extremely close to you? These are all indicators that something is in your personal space. Getting rid of an attachment that has invaded your tattoo portal space can be a bit more challenging. Usually Reiki or vibrational medicine can alleviate the problem.

To some people, the idea of energy attachments may seem foreign, but our exploration of consciousness rolls out all of the mystical, magical, and supernatural qualities of energy. We are so accustomed to only sensing how our body and physical world are affected by things. When you take it up a notch, it certainly gets a

little more interesting. Hopefully, you will have a more enhanced perspective on getting a tattoo. Aside from art and body placement, you also have the subtle bodies to consider.

We are what we think and we are what we ink. Next, let's explore the archetypes and shadows we dare to wear.

Chapter 5

Archetypes: Who Do You Dare to Wear?

Did you ever think of tattoos as a form of self-divination? The archetypal energies of the emerging self held within tattoos offer you the opportunity to have a transpersonal experience. They reveal your own unfolding story, marking events and memories by creating a dialogue linking self to self. Your ink can be a means for crossing the bridge between the unconscious and conscious, to show how the psyche has developed a perceptible means of intuiting a way to become whole. The unconscious communicates via symbols, and we recognize them in images and emotions. These symbols hold cryptic messages about your soul's journey and your archetypal influences throughout many lifetimes.

The subject of archetypes is synonymous with Carl Jung, a Swiss psychiatrist, although the Greek philosopher Plato is the founder of archetypes, which he called the *Theory of Forms*. Jung took Plato's theory further to explore the power of the unconscious and advance the idea of archetypes for contemporary times. He noted that within the collective unconscious, there exists a number of archetypes that we can all recognize. Jung saw them as symbolic keys to truths about the human condition and the path of personal enlightenment.

There has been a paradigm shift since Jung introduced his findings about archetypes, and as our exploration of consciousness advances, so does our understanding of archetypes and their role in the integrated body, mind, and spirit. Tattoos are permanent reminders of who plays on your team and can reveal your expressed emotions as well as the dark side of repressed emotions, known as the shadow. (We'll delve more into the shadow later on in this chapter.)

There are as many archetypes as there are situations. Archetypes are not symbols in and of themselves, but rather they call forth symbols as a means to communicate with the conscious mind. For example, when I ask you to describe an image for *mother*, this archetype's symbol may present itself as a piece of apple pie, the color pink, a mama bear, Earth, or the likeness of the Egyptian goddess Isis, the

mother figure. The shadow side of *mother* is the difficult woman who may symbolically be recognized as a dagger, the color black, a mythological beast, or the likeness of Hel, Norse goddess of the dead, a fearsome sight with a face half-human and half blank.

The images you ink are subjective of your story. Delving into the archetype symbols of your tattoos makes you think. They may even make you a little uncomfortable, but this brings you awareness that leads to change and opens a dialogue with your psyche. These symbols brought forth from archetypes may even represent memories from a prior incarnation. Just like your tattoos have a story to tell, so do the many archetypes you have experienced throughout your spirit's timeless journey. They are encoded in your consciousness as emotional patterns and imprints. You embody these energy imprints, which show up from lifetime to lifetime.

Some of the more common archetypes we may embody are the Innocent, the Lover, the Hero, the Sage, and the Magician, just to name a few. They can also be realized as animal archetypes, like a bear or a serpent, and even objects like trees or streams. They can be colors, shapes, numbers, planets, the sun, and alien beings. There are a multitude of archetypes—some are known, and many others have yet to be discovered. They are the cast of players in your story. The role they play in your life is subjective to you. Though everyone may possess similar archetypes, they are about you finding your unique truth and knowing your light and shadow.

Archetypes and inner journeying

Your journey begins with your intention for wanting to get a tattoo. When you get inked, you are taking part in a ritual to cross the threshold, the veil between the conscious and unconscious mind. This begins your quest for inner wholeness. Delving into the primordial waters of your unconscious brings forth a wealth of knowledge and deep healing for your spirit. Understanding the past helps you to

resolve inherent conflicts and traumas so you are less likely to repeat patterns in your life that no longer serve you any purpose.

The art and images you wear are very revealing of your archetypes: who hurts you, who heals you, and the familiar guides who help you get through this journey. As soon as the ink touches your skin with an image or symbol, you embody and sense the power of that archetype come through you. Looking deeper than the surface of the skin reveals energy and emotion that bring the emergence of the soul into present awareness.

Tattoos have evolved throughout the ages and we can now understand that the symbolism is representative of an archetype. Your ink's ancient roots in mysticism remain and can be a modality for self-realization and self-actualization. Tattoos were and always will be a rite of passage, as you cross from one phase to another. A certain life event or inner desire was acknowledged in ink. A decision was made, and you committed to the change it brought to your skin. A transformation is felt on all levels of the subtle bodies.

So, let's get down to it. Who are the archetype players on your flesh and what are they revealing? You may have intuitively felt drawn to a certain image because there is a message for you within. Your spirit wants to speak. Jung used 12 primary archetypes he felt were part of the collective unconscious, passed down through the ages in stories, myths, and religion. Those 12 archetypes are the Innocent, Everyman, Caregiver, Lover, Trickster, Outlaw, Explorer, Creator, Hero, Magician, Sage, and Ruler. These are archetypes Jung believed everyone encounters at some point in their life. There are many more than those 12 primary archetypes, because they also give birth to subtypes and situational archetypes. (Jung himself allowed for an unlimited number of them.)

Tattoos that embody the Hero archetype can be, for example, ones that commemorate accomplishments, such as tattoos for courage. Someone who has overcome a disease may sport a lion tattoo as

a reminder of their fearlessness. Other tattoos have be inked to bestow magic to enliven or embody the Magician archetype. Goddess tattoos also are often inked to connect with your inner alchemy. Tattoos may also mark criminals with certain symbols to reveal the archetype of the Outlaw personality. Mandalas were symbolically inked to provide healing and invigorate or embody the Healer archetype. (I bet by now your tattoos are beginning to seem more alive and meaningful as they expand beyond your original concept!)

You more than likely have numerous archetypes at play in your psyche; however, one archetype tends to be the alpha and dominate your personality. Whenever there is a major decision, your main archetype will win out over the others. The archetypes you embody have probably been with you a long time, so reach back and see if you recognize any patterns. The tattoo you most identify with likely holds the influence of an important archetype for you. Even if you only have one tattoo, there lies within it the voice of your inner soul.

Tattoos show your brand or personality by the symbols you ink and are revealing of the archetypes with which you identify. Are you inked with brave mythological figures depicting the Hero in you? Is your Magician persona revealed in your celestial image ink? Or is your inner Warrior declared by your tribal band tattoos? Identifying your archetypes is like going on your own shamanic journey to explore the Otherworld, the realms of consciousness.

Tattoos open the portals to the dimensions of your spirit. Your intention serves as the gatekeeper to decide which energies you are ready to embrace and fully embody. Your ink may serve as a map that reveals the journey into your subconscious, the lower world. Tattoos that mystically represent archetypes of the lower world may speak in symbols of animal totems, nature, trees, elementals, rivers, mountains, fish, mythical animals, tribes, and past-life personas.

The middle world, everyday reality, reveals archetypes through symbols representing what you are currently experiencing, such as a tattoo of your favorite sports team or the birth of a new baby. This is the part of ourselves readily accessible *to ourselves.*

The upper world, the higher realms of consciousness, is the home of angels, celestial beings, planets, astrological signs, and the expanded imagination. These archetypes may speak through symbols of ancient geometry, crosses, deities, spaceships, wings, and even memorial tattoos as remembrances of passed loved ones.

Look at your tattoos. What are they telling you about your strengths and challenges? What energies are you allowing to become present in your life? The law of attraction also applies to tattoos so what you call forth will attract similar energies to you. If you consciously tattoo, you will have a better understanding of what symbols or archetypes you are adding or enlivening in your personality. These inked-on imprints will stay in your consciousness for eternity. There is an uncanny psychic connection between the past, present, and future. We travel through these wormholes through our imagination, dreams, and creative outlets (such as tattooing).

The goal is to transform and shift the ego, which is judgmental, into its higher nature, better realized as the self. The self is an integrated energy of body mind and spirit. Interestingly, Jung, who most likely didn't have a tattoo, saw mandalas as archetype symbols for the self. If you have a mandala tattoo, you can consider that to represent a deep healing for somewhere in your consciousness. Ask yourself what was going on in your life when you got inked with this symbol that holds powerful energy.

Your tattoos capture all of the stories and memories that are contained in your consciousness, and the art and symbols reveal the archetypal influence. Tattoos, in their true sense, are mystical art and offer us the perfect vehicle to better understand our cycles of

spiritual evolution and our immortal soul. The art and images we ink on are spiritual birthmarks. They mark time. They make you ask, "What was birthed in my life when I got this tattoo?"

There is a strong connection between tattoos and transformation. Tattoos are symbolic of death and resurrection. Once something is brought to the surface, we shift. Your ink can reveal the birth of a new archetype, or resurrect a long-buried archetype energy you need to consciously embody in order to facilitate or recognize change within yourself. Sometimes your ink can serve as a reminder for what you are letting go of, so the cycle of spiritual evolution can continue. The symbol of the skull, an eerie reminder of death, is a popular tattoo associated with change. It can represent the archetype for the person, persona, or situation that was your impetus for change, which is part of the symbolic metaphor of the death and resurrection cycle for the spirit.

Through every incarnation, it is the Hero's journey. You meet your inspiration, your helpers, your nemesis, and return to center. Your spiritual journey can be viewed through your tattoos that coincide with life's challenges. Any self-discovery is like walking through a labyrinth. A labyrinth is an archetype with which we can have a direct experience. Your tattoos are symbolic labyrinths that create a sacred space and place. They can take us out of our ego and shift our awareness into *that which is within.*

Meeting your archetypes through your tattoos is a right brain task. It involves intuition, creativity, and imagery. Tattoos come with a choice to be made (to ink or not to ink) in order to cross the threshold into the dimensions of your spirit. They offer you the opportunity to view the allegory of your journey to the center of your deepest self to give you a broadened understanding of who you are.

Tattoos and the shadow archetype

There are some tattoo images that are inspired by the shadow archetype, which we briefly touched upon earlier in this chapter. The shadow is the part of ourselves we have not reconciled and is associated with our repressed urges and emotions. As the word "shadow" implies, this archetype is often seen to be a dark or negative force, although the shadow isn't necessarily bad but rather a hiding place for our more latent forces. Anything suppressed or denied in the personality is a shadow.

You may repress your creative, sexual, mystical, or forceful nature, or any other attributes buried within you, because you don't feel confident enough to express these qualities to the outside world. Tattoos may be the perfect outlet to represent your shadow archetype. In a cloaked manner, you will have brought them to the surface by allowing the tattoo portal to hold space for the shadow energy to be visually and emotionally realized. Tattoos may offer you a comfortable way to express a repressed archetype that needs to be incorporated into yourself to facilitate a return to wholeness.

When you look at tattoo imagery that subjectively represents your shadow, you can get a glimpse of repressed emotions that make you uncomfortable. You might wonder why anyone would want to go looking for their shadow. Our shadow is revealed when something is blocking the light from our higher self. Without light, there would be no source from which a shadow could be cast. Shadows have their birthplace in the light and are a derivative, or shade, of our higher potential that gets skewed off course due to factors usually originating in self-doubts. Sometimes the shadow archetype compels you to acknowledge it and finds an intuitive way for you to express this emotional energy.

The shadow is a natural part of the personality. Meeting the shadow through our tattoos is a meeting with our own reality, which in

turn enables us to look at ourselves more realistically. If the shadow can be met, it leads to wholeness. A main feature of many archetypal figures, particularly of the shadow, is their autonomous activity in us. Jung implied that meeting our shadow helps us be more inclined to not pass judgement on others because we have already recognized these attributes in ourselves.

Tattoos can be an enlightening part of your soul work journey. The shadow self is an archetype that forms part of the unconscious mind and is often described as the darker side of the psyche, representing wildness, chaos and the unknown. We all own these latent dispositions, and in many instances, they are a strong source of creative energy. You might see a girl with a bold aggressive tattoo and think, "What the hell was she thinking?" Her tattoo makes you uncomfortable because it represents the part of you that wants to be bold and out there. A shy guy may get a sexy tattoo because he needs to express the archetype of his repressed mojo. Tattoos that symbolically express a shadow archetype are usually imbued with very active energy that is just ready to jump out of your skin.

Conscious ink is about owning, accepting, and expressing yourself through your tattoos and honoring who you are. All of the archetypes need a symbolic voice from the good, the bad, and even the ugly. Letting these out in a creative way keeps you from bottling up heavy emotional energy that may lead to a physical, mental, and spiritual imbalance. Soul work through tattoos is not just about recognizing the feel-good archetype images; you can't go chasing just the light and higher vibrations. You have to transmute the lower archetype energies in order for them to entrain with a higher vibration. This is done by exposing your wounds, accepting your shadow as well as your light. We can't ignore the entirety of what it means to be both physical and spiritual at the same time. Wholeness is about functioning as one unit with no separateness between the body and spirit.

The tattoo symbols you feel represent your shadow let you recognize your nemesis archetypes. They symbolically serve as visual reminders so you don't necessarily feel pulled to physically act out your shadow side. In order for any healing to occur, good and evil must overlap. It's not light or darkness that creates the healing, but the meeting point where they both touch.

Art is one of the highest forms of self-expression, as well as a great way to allow your shadow to manifest itself. Tattooing lets you ink whatever comes to mind and touches you in an emotional way. The process of getting inked stimulates emotional energies within the body, mind, and spirit. It's an outlet for you to feel emotions. Some emotions may be shadow or darker emotions you spontaneously feel as the tattoo is being inked onto your skin. Pay attention to what you are feeling and how it relates to your symbol. The urgings of the shadow may have been released in the form of awakening tattoo art. Awareness of the symbol, and its related emotions, helps you to gain insight into your shadow self and reveal more about your obscure inner half.

When we meet up with a tattooist to talk about creating a tattoo image, we usually have a moment when we think, "Do I want go there? This is going to be a permanent mark on my outward persona." The reality is that beneath the surface, you are awakening an archetype, which will tap into the stuff we don't show people—or even ourselves.

So, you might be wondering if there are any clues to figuring out your archetypes before you commit to a tattoo. Archetypes fill the landscape of your dreams. Many people are often inspired to get a tattoo because of a vivid dream. You may find that after getting a tattoo, your dreams seem more lucid and meaningful, as if you woke up the sleeping archetypes within your consciousness. Whenever you do soul healing work, your archetypes that support your shift into a higher vibration have an uncanny way of showing up.

Archetypes: More than your ink

Remember, archetypes aren't symbols but rather talk to you through symbols. It's a little tricky. Put your logical left brain aside and remember there are no wrong answers. The symbols you associate with your archetype are subjective to you. Identifying your archetypes is like finding your inner voice. When deciding to get a tattoo or even looking at your existing tattoos, you will intuitively know what the symbols and art mean to you as representatives of your archetypes. Archetypes are all models after which other things are patterned. Even tattoos that are just geometric shapes, a series of dots, or swirls of mixed color bring an emotion, thought, or image to mind.

Archetypes tell stories; you most likely have a story that goes with your tattoo. There are thousands of archetypes but as we already mentioned, we theoretically categorize each incarnation within a core group of 12 (as identified by Jung), although many others may pop through so you can pull forth some buried knowledge and wisdom as you journey through this incarnation.

Your tattoo can also stimulate a sleeping archetype etched into your consciousness from a prior lifetime. Knowing your ink has such transformative powers allows you to consciously make this permanent commitment. Your tattoos of today will stay encoded forever into the memory of your consciousness, your spiritual essence.

Because this book is about consciously tattooing, be observant of how to work with the archetypes that want to assist you in this lifetime so you can travel on as a higher vibration into your future incarnations. Remember: tattoos are a great source for self-divination and give you a better understanding of your spirit's travels through each and every lifetime. The journey is always about evolution of consciousness, the continuous death and resurrection experience.

Archetypes, even though they are an abstract concept, are more accessible to you than you might think. You just have to be aware so you can more easily interpret what message and influence they contribute to your patterns of behavior. In a psychic way, archetypes provide guidance, so pay attention to the subjective meaning they might assign to synchronistic events. For example, let's say you had a dream about the yin-yang symbol, and the next day someone hands you a pamphlet with the same yin-yang symbol on it. This symbol may be a reminder or a sign pointing you in a specific direction. The coincidence is the appearance of the symbol in the dream and then in physical reality. The meaning is derived by the feelings, thoughts, and actions it inspires for you. You may decide to have that symbol tattooed on your body to experience and embody the full essence of its meaning. This is where discernment, intention, and subjective meaning come in to play. Always ask yourself what the symbol means to you. Pay close attention to the emotions you feel when you look at a symbol because archetypes speak through images and synchronicity when the meaning of a coincidence is applied to life.

We exist in more than just the third dimension of physical reality. Whatever you do now echoes through your consciousness and vice versa. Past patterns from eons ago filter through to this lifetime and hopefully become more refined as you absorb the meaning of the knowledge and lessons about yourself that they provide.

Consciously being awake exposes you to the mysterious, hidden information in your consciousness. If you want your tattoos to reveal their deeper meaning, then see them as your personal archeological dig that reveals your spirit's acquired knowledge throughout the totality of its incarnations.

The 12 universal Jungian archetypes

Let's look at the 12 primary, foundational archetypes (plus their corresponding shadows) so you can better understand their emotional energy and influence on the psyche. The more astute you become to how they reveal themselves through symbols and imagery, the more likely you are to see your tattoos as a very therapeutic means to get to better know yourself.

Remember to keep in mind that the communication lines between you and your consciousness work both ways. You may get a tattoo without actively looking for a deeper meaning, then afterward begin to experience synchronistic events connected to your tattoo. You notice these happenings when you stay present and aware as you move through your life. You begin to live a conscious life as opposed to an automatic life.

The Innocent

The Innocent is the Dreamer, the Inner Child in you. Here lies the happy, optimistic, and somewhat naive archetype. You want freedom of self-expression for yourself and others, but you also must be wary of being taken advantage of by people. You may cling to remaining loyal when loyalty is not deserved. (Time to remove the tattoo with your old lover's name!) Your biggest fear is being rejected or abandoned. You may be prone to attracting people with severe problems or possibly abusive behaviors.

In Greek mythology, the Innocent is represented by the goddess Persephone. Persephone, youthful and naive, was abducted and brought to the underworld, therefore losing ties with her family. The Innocent, like Persephone, often faces trauma in childhood, emotional and/or physical. The shadow of the Innocent archetype is the **Weakling**, a person who becomes codependent and needy.

The abdomen is the part of the body we usually associate with vulnerability, in addition to the heart and ankles. What tattoos do you have in those areas? Those images may express your Innocent archetype or the shadow of dependency. When we think of innocence, you may imagine the symbol of a dove, a silly icon, the color white, spring flowers, or even a tattoo you inked to mark a pain or disappointment from a relationship, such as a hammer on a heart. A tattoo of a seagull, which symbolizes freedom at first—and then dependence—might be a tattoo symbolizing the Weakling. Most likely it would be on the ankle, the body area for support.

Being aware of the Innocent archetype helps you to better incorporate it into your psyche and remove old patterns of behavior that are no longer valid.

The Hero

The Hero is the Warrior, Rescuer, or Leader you embody. You believe anything can be achieved if you put your mind and determination to it. You believe in courage. Your greatest fear is being thought of as a coward, weakling, or vulnerable. You want to have triumph over adversity. The shadow side is the **Insolent**, arrogant and always looking for the next battle.

The Hero can be realized as a man, woman, or animal archetype, such as the lion. The colors black and red indicate strength and determination. A tattoo image of a dagger or sword may be the embodiment of the Hero who fights their way through adversity. You can see the Hero in both the ancient Greek myth of Jason and the Golden Fleece, as well as modern superheroes like Superman and Wonder Woman. Mentors in your life can also embody Hero archetypes. The antihero, the Insolent, may ink tattoos of a socially offensive nature such as the swastika, most likely on a visible spot just to incite someone.

Your back, arms, and shoulders identify with courage and strength. Do you have a tribal band tattoo to embody the Hero

archetype? Look to the tattoos you ink on your back, arms, and your shoulders for clues to the source of the archetypal power you embody. We all have our battles, but recognizing where you draw your strength and how you use it helps you to overcome adversity.

The Caregiver

The Caregiver is always striving for positive energy. You are compassionate and self-sacrificing, and usually seen as the Altruist, the Saint, and the Good Parent. You dedicate much of your life to caring for others, and fear not being appreciated or being taken advantage of for all that you do. The shadow side is the **Wounded Healer**; they're those who must suffer the wounds of life to understand it. Wounded Healers fall into the mindset of victim consciousness and believe no one cares about them.

The Caregiver archetype can speak through symbols such as the shaman, the peace sign, angels, your pet, the word "mother," and the colors blue and green. Dolphins can also symbolize Caregivers. Greek legends state that dolphins were responsible for carrying the souls of the dead to the Islands of the Blessed. Tattoos that look like a bullseye target, arrows, and the number 0, placed on the hands or chest, are some examples that can symbolically show the archetype for the Wounded Healer.

Tattoos near the heart and on the hands may be significant of how you care and the shadow of how you hurt. Some people who have overcome an addiction or condition may symbolically tattoo a word or message as a reminder to care for themselves.

The Everyman

The Everyman is often called the Good Neighbor, a Regular Guy or Gal. Your biggest desire is to connect with people around you. Your biggest fear is to be left out or to feel like an outcast, while also losing your personal power or sense of identity due to your

desire of sameness. You don't express your individuality as much as you should, so you usually stick with playing it safe. Your virtue is being ordinary. The concept of the ordinary man came about during Medieval times. No Greek myth relates to this archetype; I guess all Greeks were heroes. This archetype falls between the true Innocent and the full Hero or Warrior. Many of our true heroes have had ordinary, humble beginnings. As an Everyman, you strive to find individuality and trust that you will not be a lamb lead to slaughter for having your own sense of self.

The shadow side is the **Cynic**, expressed as an us-versus-them mentality. The Cynic is very protective of their own turf, to the exclusion of seeing people or situations clearly. Because they want to fit in so badly and belong to a group of some sort, they might begin to lose themselves in their effort to blend in. Their disdain for authority and lack of trust in the rules of the system leads them to find security joining extreme groups or gangs.

The Everyman plays it safe and considers getting tattoo symbols such as simple initials, group or team insignias, or a discrete small tattoo with minimal color. Whatever the tattoo may be, it's usually placed on a part of the body that is easily hidden. The shadow Cynic side may be expressed in symbols representing gangs, dissident group insignias, a question mark, or the grim reaper, most likely on their least dominant arm because they don't draw from full strength.

The Outlaw

The Outlaw is often called the Rebel, the Nonconformist, the Maverick, and the Badass. Your motto is *Rules? What rules!?* Watch out if someone does you wrong because you will invest everything in taking revenge. You are full of surprises and don't mind disrupting the normal way of doing things. You crave excitement but can easily cross boundaries hurting others and yourself in the end. As

an Outlaw, you're a free spirit, a revolutionary, and a radical noncon-
formist. Your biggest fears are feeling powerless and the finality of
death. Think of the Greek myth about Prometheus, the rebel Titan
who stole fire to give it to mankind. The shadow can come across as
the **Peacemaker**, seeking approval of others by appearing convicted
and certain of themselves and their truths. They politically influence
the crowd.

Any tattoos that are outrageous and provocative symbolically
speak the voice of the Outlaw archetype. Images of owls, hawks, ra-
vens, the color yellow, and expressive skulls are some symbols that
may represent this archetype. (Tattoos of a strong bird, like the eagle,
are often indicative of the Outlaw archetype.) The shadow side sym-
bols may be insignias for law enforcement, a dove, or a dragonfly
tastefully placed on the body.

The Outlaw likes to push boundaries so any and all body flesh is
an open canvas for ink. The Outlaw needs to develop self-awareness
and see the fine line between being a revolutionary or a peaceful re-
former like a hippie or free spirit. This requires humility, something
the Outlaw sees as a weakness.

The Explorer

The Explorer is viewed as an Individualist, Pilgrim, Adventurer,
and Seeker. You strive to be authentic and have a desire to be free
to explore new things in order to find yourself. You like excitement
and want a big life, full of joy and growth. Your biggest fears are
being trapped in unhappy life circumstances, conformity, and feel-
ing empty inside. You like to seek out adventures for the pure ex-
perience. You set very high standards for yourself and others, and
fear ever having to compromise your values. The Explorer brings
to mind Odysseus, the explorer on a quest to return home. The
shadow of the Explorer is the **Introvert**, who is so self-involved

that they create an alienation by building walls and, as a result, become misfits.

Symbols for the Explorer include images of sharks, the sun, the color red, and dragons. Tattoos for the Explorer may have lots of shading and depth, looking as if they hold hidden passages to be explored. The Introvert may play it safe by choosing a discretely placed, contemporary image that is trending for the moment, should they even consider a tattoo. The body parts that resonate with the Explorer archetype are the legs and feet, because they move you forward in life. The Explorer goes forth to discover the world and their own inner self, but risks isolation if they shut others out in the process.

The Lover

The Lover believes in "The One," true, passionate, devoted love. This archetype finds satisfaction and fulfillment through intimacy and commitment of some kind. Though the object of devotion is often another person, it can also be an animal or even food. You desire an exciting life to be shared with your loved one. You feel incomplete without your other half, which is why your goal in life is to become extremely attractive—physically, emotionally, and spiritually—so when you will meet "The One," you will be ready for them. What you fear most is being disappointed by people you believe in or not being adored and loved enough. You fear losing your individuality by believing in a partner who really isn't ideal, therefore hurting yourself in the process. The Lover is expressed in plenty of myths such as the Greek myth of Cupid and Psyche. It is even dotted with some drama, like most love stories. The shadow is the **Insatiable**, a person who is envious, jealous, possessive, promiscuous, and sex-addicted. The shadow side comes from the insecure feeling of not being loved enough and becomes a glutton in their pursuit of being satisfied.

Tattoo symbols for the Lover can be the heart, a rose, a Celtic love symbol, a lover's name (although most tattooists think this is bad luck!), the goddess symbol, and images of things that evoke the emotions toward the people or things you love. The shadow side of the Lover archetype may go for tattoos that are overly sexy, verging more on porn than art. They like to ink on the most provocative body parts.

Tattoos that generally symbolize the Lover are usually placed close to the heart or on the arms and hands where we show how we embrace the things we hold dear. Tattoos of passion are usually at the base of the spine and near very private body parts. The Lover has to integrate both physical and mental love, and be wary of obsession and possession. This is a very strong archetype closely related to the root chakra of primal love and sex. The *kundalini* energy revs this archetype up and the challenge is to incorporate a balance between physical love and emotional love.

The Creator

The Creator is also called the Innovator, the Writer, Musician, Painter, Dreamer, and Artist. The Creator archetype often acts out of inspiration or even out of dreams or fantasies. Your imagination and artistic nature can create amazing modalities for self-expression. You are a visionary and strive for positive change. Your biggest fear is failure, which would lead to losing hope and never realizing your dream. The shadow side is the **Perfectionist** who spends so much time with the details that they risk not flowing with their creative urge. This can lead to frustration and many unfinished projects. There is also the tendency to act like a prima donna and come off as quirky or odd.

The Creator archetype is what got the whole ball rolling. You just have to look at any of the creation epics and myths to recognize the Creator archetype. Tattooing was most likely inspired by the Creator

archetype. Tattoo images that are birthed from dreams, surreal images, fantasy, and mythological creatures; the Greek goddess Isis; the color yellow; and lightning bolts may be some symbols that speak the voice of the Creator archetype. The Perfectionist may have tattoos that are overdone, or lacking true originality. No matter where they tattoo, they're never satisfied.

The part of the body that is the most avant-garde appeals to the Creator when it comes to tattoo placement, such as the inner thigh and top of pubic area. The Creator archetype is at their best when focused internally and able to channel their imagination, dreams, and creativity into a reality.

The Sage

The Sage is also called the Scholar, Philosopher, Expert, or Mentor. You believe life is about knowledge, because knowledge is power. You are in touch with your higher self and your ability to transcend difficulty. The Sage is intellectual and inquisitive in nature, and you love to understand thought processes, human behavior, and the world. Your biggest fears are illusion or being deceived. You are very astute but, due to your contemplative nature, might overthink things and delay action. When you think of wise men you can't help but think of Socrates, a great Greek philosopher, possibly the wisest sage of all time. The shadow is the **Critic**, who even though possesses knowledge, becomes critical and judgmental toward others who look to them for advice. The Critic has a strong ego and is unforgiving when lied to.

Tattoo symbols that may represent the Sage archetype are Buddha, trees, the color green, and four-leaf clovers. The shadow may prefer images such as decorated masks or have many cover-up tattoos, most likely on highly visible areas as a result of making some bad choices. Neck tattoos energize the voice of wisdom for the Sage. It's an archetype that helps advise people as they go through

their steps of personal transformation. The wise knowledge the Sage shares with others is best realized as discerning guidance without harsh judgement.

The Jester

The Jester is also known as the Trickster or the Wisecracker. You have an engaging nature and believe life should be fully lived with fun and pleasure. You live in the moment, rely heavily on your wits, and are willing to cross boundaries, break taboos, or say the unmentionable. As a Jester, you are full of humor, sarcasm, and irony. You fear, more than death, the idea of being bored or being boring to others.

Here is an interesting fact about the Jester: this archetype is a shape-shifter and has the potential to change and transform. In the study of folklore and religion, a Trickster is a spirit, man, woman, an alchemist, a shaman, or anthropomorphic animal. Think of the Greek god Hermes, also known as something of a trickster, stealing Poseidon's trident, Artemis' arrows, and Aphrodite's girdle. Your shadow is the **Pragmatist**, who sees life from a careful and serious side and thinks before they speak. They manage time well and get much accomplished. The Pragmatist is more the Wise Fool, having learned from past mistakes and idiotic ways.

Tattoo symbols for the Jester may be cartoon characters, a praying mantis, a bee, a lizard, the color orange, images hidden within images, and anything taboo expressed in a fumy sort of way. The Pragmatist, meanwhile, may prefer symbols that are more discrete and basically made up of small symbols, such as sigils, dot work, small stars, or a thin tribal band.

The Jester will tattoo their face or their ass because they think it'll be funny, whereas the Pragmatist sticks to the safe, upper arm area. The Jester does well to remember that you can play but also strike a balance with the more serious side to life.

The Ruler

The Ruler is often called a Micromanager, Leader, King or Queen. You crave control more than anything else because you believe power is everything in life. You are responsible and have big desires in creating the perfect family, business, or community around you. Because of your intense authoritarian nature, you can come off as being too pushy. You fear chaos and being sabotaged by those working for you. In Greek mythology, the Ruler would be Minos, a mythical king in the island of Crete, the son of Zeus and Europa. He was famous for creating a successful code of laws. The shadow side is the **Manipulator**, who connives to get what they want because they don't feel secure enough in their own skills to accomplish things. They twist and turn things around and conspire to create chaos. Divide and conquer is their code.

Tattoo symbols fit for a Ruler archetype could be a crown, chalice, octopus, whale, or an inverted triangle (which symbolizes water). The Manipulator may prefer to copy someone's original ink and claim it as their own. They also can be symbolically recognized as a winking eye, rodent, or climbing vines.

The front of the body suits the Ruler well for tattoos, whereas the Manipulator may prefer the back or places on the body that remain covered or hidden. The Ruler can envision how to create structure and order, and it is best realized if there are no underhanded methods or tyrannical behavior.

The Magician

The Magician is also known as the Enchanter or Enchantress, Inventor, Healer, and Wizard. You have knowledge of the physical world, and know how to use it to forge solutions to problems. You frequently act on hunches or intuitions. Your biggest wish is to embody all your power and discover the universal laws through which

you can make desires become reality. People often find you interesting and your perception is uncanny. Your biggest fear is rushing into something without making sure you will not suffer unintentional negative consequences as in magic gone wrong. In Greek myth, the Magician relates to Hecate (goddess of the moon and witchcraft), Orpheus, and Circe, the sorceress daughter of Helios who was expert in magical herbs and potions and who helped Odysseus summon the ghosts from Hades. Your shadow is the **Evil Sorcerer** or **Wicked Witch**. They use their mystical skills to manipulate situations, give false prophecies in order to gain control, and are not beyond working with the dark side of magic.

Tattoo symbols for the Magician archetype could be celestial images, deities, Norse runes, wizards, and a personal animal totem, such as a snake. The Evil Sorcerer and Wicked Witch symbolically speak through dark images, and deities of the underworld. Images tattooed on the index finger of their dominant hand help them to project their dark magic.

The hands are the ideal place for Magician tattoos as well as the inner arm and wrist area. The Magician is best realized as a healer who uses their knowledge of energy and manifestation in a way that is helpful and healing barring any use of manipulative magic.

The associated symbols for the above archetypes are only suggestive and not carved in stone. You can decide which symbol speaks the voice of your archetypes depending on your firsthand experiences. As stated, there are numerous archetypes we can embody and as our civilization advances, more and more archetypes enter the domain of our psyche. Dream symbols represent much information about your archetypes, but sometimes it is hard to recall them unless you keep a dream journal next to your bed.

One never knows what will bring out a strong archetype for the emergence of the soul. Guy Crittenden is an award-winning independent journalist who lives in Toronto, Canada. Guy recanted his experience in honoring the symbolic appearance of a very powerful archetype that personifies his calling to be a shaman. In Guy's words:

> Back in 2001, when I flew home to Toronto from a business trip in London, England, I'd sat beside a woman who had a beautiful tattoo of a snake that spiraled down from her shoulder to her hand, where the jaws opened onto her thumb and forefinger. We spoke for about 20 minutes, and she told me about visiting *curanderos* (shamans) in the Peruvian Amazon, traveling upriver by dugout canoe to drink their visionary psychedelic brew *ayahuasca*.
>
> It was early 2014, after I returned from Peru where I experienced drinking *ayahuasca*, a spirit animal began to appear at different times of day or night— black markings on a background of white light as incandescent as a welder's arc. It would fill my field of vision for about 20 minutes, causing me to stop whatever I was doing at that time.
>
> Over the course of two years, I cracked the code of the snake's significance. I'd been called to a shamanic path, and in time felt compelled to put my spirit animal on my body. It should never have surprised me that it would be a snake, since a snake was *ayahuasca's* first communication with me.
>
> Unsurprisingly, a black snake now spirals down my left arm, its mouth encompassing my thumb and forefinger. She is Pachamama—Mother Earth in the cosmology of the Quechua people of the high Andes, who deem dimensions for separate realms:

Sachamama (the two-headed snake who is the mother of forests), Yukamama (mother of rivers and water), and Wayramama (mother of the sky and air). My tattoo represents them and also contains tribal patterns that represent a journey.

Traveling through the body of the serpent as far as my elbow, two designs overlap in layers, one of them distinctly Shipibo. On my upper arm and shoulder there are three layers of design, still honoring the Shipibo but at this point a metaphor for the many dimensions of the immersive *ayahuasca* dream state.

Receiving my tattoo was a spiritual or shamanic experience in itself. I resolved to not acknowledge any pain during the procedure, which I treated as a meditation on non-duality or Oneness. (But damn, did the index finger hurt!) At times, perhaps because of the endorphins pouring into my bloodstream, I caught glimpses of sacred geometry and other visionary experiences of a shamanic nature. The design was directly sketched on my arm, not on a sheet of paper, and improvised a bit over the course of several long sittings.

It was an exercise in trust, letting go, and ultimately, transcendence. Now the serpent is on my body and inside me. I am the serpent, the mystic, living the shamanic archetype, walking the path of the Magician.

Becoming familiar with the 12 primary archetypes can help you gain perception of values, motivations, and behaviors in yourself and others, and give you an idea of what archetypes you

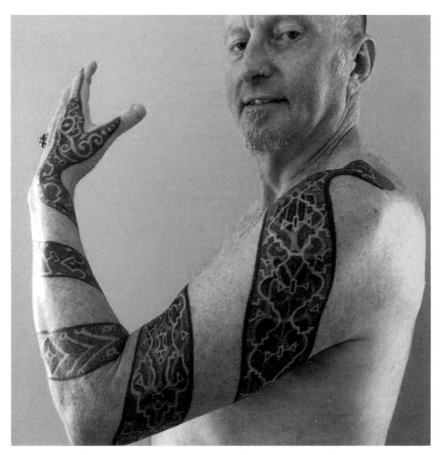

Tattoo by Daemon Rowanchilde. Photo by Raven Rowanchilde.

symbolically embody through the tattoos you have on your body. The shadow is the easiest of the archetypes for most people to experience, because they usually project it on others though we may deny it on ourselves. We should recognize the hidden side of our personality and take responsibility for it. Maybe tattooing symbols that reveal your shadow would make you less likely to project it out toward others.

By now you are probably ready to delve into the symbolic language of the energies and archetypes you embody through your tattoos. Your ink serves as a conduit, a direct channel to your soul.

SYMBOLS AND THE LANGUAGE OF THE SOUL

Looking at tattoos as a way to view the emergence of your soul is a new concept that has ancient roots in man's once-close association with the realm of spirit. Emotional energies become incarnate through tattoo symbols. Your inked images are the interpreters between the seen and unseen realms in which we quantumly exist at all times. Understanding your tattoos beyond the ink is a bit like learning a new language, because nothing is what it appears to be on the surface. There is always a deeper meaning attached to some emotion or memory. Tattoos and the symbols you embody can be powerful tools for accessing self-knowledge. Your ink can initiate an inner healing, mark a transition in your life, and be a creative outlet for authentic self-expression.

Tattoo art, symbols, and even the light and dark of the colors used for shading are actually a mirror of your inner world. Tattoos reflect your inner architecture and current mindset as you move through life. The art and symbols can best be understood if you approach them the way you would the metaphors in a poem, when symbolic language is used to capture the deeper essence of an unspoken idea or feeling.

Tattoo images and symbols may appear to be easily defined visually. For example, say you got a tattoo of a turtle. To the eye, the image of a turtle appears as an animal but this symbol connects into your consciousness and reveals a deeper message. The turtle represents patience, longevity, inner wisdom, and home. It connects to the wisdom of your inner Sage archetype. Its expression is even further realized by looking at the part of the body that carries the emotional energy expressed through this tattoo image. The turtle symbol makes you ask, "Where do I have to slow down, where do I need patience?" Once that part of you receives the information, shifts in your consciousness occur at a deeper level. You didn't know that the turtle image already answered your questions. In an intuitive way, the image inspired you to begin considering ways to approach your

problem. By realizing your connection to the energy of the image, you are able to access the hidden knowledge in your consciousness. This can bring about synchronistic events where things begin to line up to provide you with much needed guidance and answers. You begin to see that everything is connected.

Tattoo images and symbols are a way to connect with your consciousness and explore the hidden yet vital knowledge of yourself that brings about wholeness. The images, symbols, and colors you choose to imprint on your body are the materialized form of what is held in the realms of consciousness. They represent your archetypes and inner guidance. Explore the adjectives that best describe your tattoos and how these qualities may currently be active or emerging in your approach to life.

Inspiration for your ink manifests from a side of the psyche that developed before language and therefore speaks in symbols. Sometimes the bizarre art, and even the common tattoo symbols, can capture the complexity of profound transformation as you tap into the clues that pop up to reveal your soul. Your ink depicts images that have an uncanny way of bringing to the surface the emotional energy in the unconscious and gives you an awareness of your psychic connection to spirit. Tattooing prompts you to initiate the full awakening of the self and understand your creative side, the building block for how you live your life.

Consciously tattooing is from a different mindset than just getting a tattoo for vanity purposes. It is about setting an intention, consciously embodying the images and symbols, to find the deeper healing, transformative powers within yourself. The most interesting journey you can take is into the self. Once you understand yourself, wholeness is achieved. You can have an awakening that affirms all answers are accessible from within if you look for the signs and symbols that hold valuable clues for accessing your amazing,

intuitive knowledge. Tattoos are a spiritual healing modality that symbolically let you access the realms of your consciousness. Here are a few of the ideas you can explore though your tattoos:

- **Health**: What symbol or image shows you where you received a healing, beat an illness, or kicked an addiction?

- **Relationships:** What reveals your relationship with yourself and others?

- **Lower World (subconscious):** What came from your dreams and the deep subconscious?

- **Middle World (conscious reality):** What relates to what is currently going on in your life?

- **Higher Dimensions (higher mind):** What represents your spiritual guides?

- **Spirituality:** What connects you to your beliefs?

- **Release:** What marks where you released the past, a trauma, or limiting situation?

- **The Hidden:** What uncovers deep connections to prior incarnations?

- **Archetypes**: What links you to your inherent patterns of behavior?

By answering the above questions, you are bringing yourself to a place of presence in your life, and your tattoo reveals all the shape-shifting your consciousness goes through in order for you to become whole. When you consciously tattoo, you are reclaiming the parts of you that are hidden, yet very powerful and vital for healing, knowledge, and transformation.

Your spirit communicates through symbols and images, so you must ask yourself what your tattoos evoke in you. Try to avoid

imposing a mental answer into your tattoo and instead, allow your intuition, and your gut feeling, to be the translator of the wisdom held in the ink. The message might come about days, or even weeks, later, but merely *asking* is what initiates the conversation between you and spirit. You will always receive an answer. It will unveil itself when the moment is right.

The more you connect with the meaning of your tattoo, the more your relationship with the images and symbols deepens and your consciousness expands. Your internal emotional energy shifts, providing you with an understanding of how you have the innate ability to co-create your personal transformations, healings, and manifested life. As you read through this chapter, reference Chapter 2, which will give insight on how the symbols and images work with your physical body and chakra centers. The relationship between physical and spiritual is only a breath apart and mystically connected. Remember, the meaning of symbols is subjective to you, your experiences, your archetypes, and your journey. A symbol takes on meaning when it is activated by your intentions and body vibration, and it uniquely networks into your spiritual essence. Your tattoos can ignite your emotions, shift your energy field, and catapult you toward an inner journey where connections are made into the channels of consciousness. Use their suggested meaning as a reference and then trust your intuition and interpret the meaning as you're guided to do.

You may remember reading about Daemon Rowanchilde in Chapter 3. Daemon's wisdom in working with the numinous qualities of symbols generates beautiful art that is both healing and transformative for the client. Daemon works with the soul print of the tattoo. In other words, the symbol and even the placement of the tattoo is guided by inner intelligence of the client. In Daemon's words, "I encourage my clients to trust their first impulse, their intuition for symbols and especially for placement."

I wanted to know how Daemon felt about symbols and body placement, and he explained it in the true sense of how the sacred practice of tattooing goes beyond skin deep: "Clients who cave under peer pressure to second guess their placement always regret doing so. Placement can reveal the kind of healing that the body is ready to transform."

Daemon shared the story of one of his clients, Dave Potwin, a police officer struggling with PTSD:

> He really wanted the lyrics of the song *Shipwreck* tattooed on the right side of his torso and front ribs. The song was the symbol of his struggle to not be drowned by the immensity of his trauma. I added water features to carry the weight of the words and make them buoyant and surfacing. At the time he came to me for a tattoo, he was processing a lot of anger over his divorce and issues at work; therefore his placement over the liver, which processes anger and also serves as our spiritual compass, was impeccable.

Daemon's use of water symbolism, along with the imbued intention of giving buoyancy to the words he inked on his client, is the most sublime example of how to work with images and symbols. Let's explore the hidden meanings of this tattoo.

Water symbolizes your subconscious and your emotional state of mind. It is the living essence of the psyche and the flow of life energy. It is also symbolic of spirituality, knowledge, healing, and refreshment. The sea has also been home to huge pearls and found treasures. Placing the tattoo on the right side resonates and reflects how you feel about your current life experiences along with representing the conscious part of us and the future. Front-facing images hold clues to the archetypes you identify with on a day-to-day basis. The abdomen area is the seat of emotions, which contain our

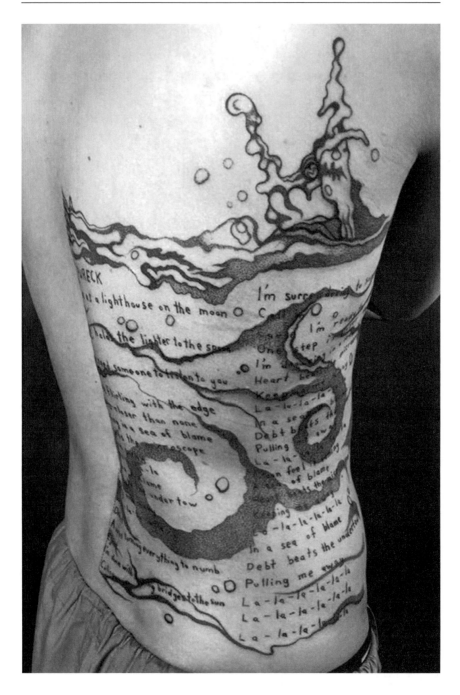

Tattoo by Daemon Rowanchilde. Photo by Raven Rowanchilde.

deepest feelings, the center of sexuality, and our gut feelings toward life.

The chest/torso area is the place for your private self: your relationship issues, heart and love emotions, self-esteem, and feelings of worthlessness are all held here. It also holds our most private wounds. Tattooing near the third chakra center radiates energy to the liver. In energy medicine, the liver is the organ that processes anger. The symbols tattooed in this area can help you refine how you use your personal power.

The boat as an archetype symbol has a powerful significance in being emblematic of making the odyssey across life; therefore, a boat can be seen as that which enables us to make such a journey, whether it be faith, self-knowing, desire, curiosity, or any other such motivation. Journeys on boats are usually long and fraught with dangers that are overcome. In a general sense, a ship setting shows how one braves the sea and death, and returns to a type of spiritual, emotional, or material rebirth. The death and rebirth theme is underlying in tattoos because there is significance in the meaning of change—crossing a threshold, the rite of passage—a ritual ceremony that brings your state of being to a different awareness. Archetypically, it can be understood as part of the Hero's journey.

The tattooist, in the true sense of the sacred art of tattooing, is your shaman who facilitates opening the portals for expanded awareness. The symbols and images of your tattoos allow you go deep into veiled experiences in the body and tap into implicit memories that are not otherwise accessible through the conscious mind. You can shift from thinking to feeling by starting with what impressions you sense in the body as the tattoo is being applied. Once the symbol or image is embodied, there is a shift in awareness and you become your own resource for being proactive in finding needed guidance, healing, and personal transformation.

The symbols we ink and sync to our consciousness

The language of the soul is symbolic in more ways than can be summarized in a sentence or paragraph, but generally we are talking about how tattoo symbols can stand for something else, how they can be used to communicate, and how they can be imbued with meaning. Most symbols can address many different things at once and can mean different things to different people. Symbols don't always have inherent meaning because they are generally given their meaning based on their usage; what we think is the obvious meaning can differ. Symbols are semantic in that they can mean one thing yet change according to how they are used by another. Sure, it's complex, but so is each individual. As the saying goes, a picture is worth a thousand words.

Because we are talking about consciously tattooing and the inner alchemy of tattoos for transformation, let's start with the four elements of fire, earth, air and water. The ancient Greeks believed everything was made up from these elements—although there is also a fifth element, ether, the element of spirit. These elements link us to the cosmos and are represented in tattoos through color, animals, nature, astrological glyphs, celestial images, deities, archetypes, numbers, and sacred geometry.

Look at your tattoos to see what elements of creation they carry forward and to where on your body you are expressing this energy, along with the emotions they provoke, and your initial intention for getting that tattoo image. Go explore.

Fire

Fire is equated with birth and resurrection. It is the Hero, Creator, and the Explorer archetypes. Fire represents creativity and determination but can also be consuming if there are no boundaries. Fire also shows passion, hatred, energy, and connection to your personal power. Where there is fire, there is also light, meaning fire has the ability to transmute or change things. It links to masculine projective energy for both men and women. Images and symbols that portray the fire element are:

- **Archangel Michael:** Protection, courage, guidance.

- **Aries:** The first astrological sign, associated with fresh vigor and unruly beginnings.

- **Bee:** Opening a healthy communication with family.

- **Celtic rose:** Purity of the heart.

- **Chili pepper:** Relate to healing and protective powers.

- **Devil:** Temptation or a playful or mischievous nature.

- **Eye of Horus:** The eye is represented as a figure with six parts, which correspond to the six senses: touch, taste, hearing, thought, sight, and smell. These are the six parts of the eye, the receptor of input, and also represents protection.

- **Fire Dragon:** A symbol of wisdom, longevity, infinity, change and transformation. Represents the supernatural and infinite self.

- **Flames:** Purification.

- **Ladybug:** A wish granter, the bringer of love.

- **Leo:** The fifth astrological sign, represents the independent element of self (the ability to express easily and creatively).

- **Lightning:** Intuition, truth.

- **Lion:** Shows courage, strength, fearlessness, bravery, and high status; also a symbol of Leo.

- **Lizard:** Dreams, the depths of other realities that are not on the physical plane of existence.

- **Number 11 or 11:11:** Illumination and insight, harnessing your power for manifestation, spiritual truth.

- **Orange:** Physical pleasure, sensuality, creativity, emotional self-expression, impulsiveness; can also indicate an outgoing social nature or stress related to addictions.

- **Phoenix:** Symbolizes virtue, rebirth, transformation, and victory of life over death.

- **Praying mantis:** Spiritual symbol of patience and stillness.

- **Ram:** Determination, initiative, action, and leadership; also a symbol of Aries.

- **Red rose:** True love or passionate love.

- **Red:** Life force, sex, survival instinct, passion, anger, anxiety, nervousness.

- **Rooster:** Emulates sexuality, observance, and resurrection (it tells us to pay attention to circumstances in our life); also represents timekeeping (roosters crow when the sun rises).

- **Sagittarius:** The ninth astrological sign; represents awareness beyond the physical world and freedom to expand to the fullest potential.

- **Salamander:** Courage, determination, renewal, energy, and solar symbolism.

- **Shark:** The hunter; adaptability, potential, survival, independence, fearlessness, power, protection, and emotional transformation.

- **Snake:** Creation and creative energies.

- **Star:** Ideals; stars may also represent a rating system, as if you are trying to evaluate a situation or establishment.

- **Sunflower:** Vitality and fertility.

- **Swords and anthems:** Strength, ambition, competitive nature, decisiveness, and willpower.

- **Sun:** The giver of life, the limelight.

- **Tiger:** Power, ferocity, passion, and sensuality.

- **Upward triangle:** Represents fire.

- **Volcano:** Unable to control emotions, particularly if the volcano is erupting.

Earth

Earth is associated with death and rebirth. The earth element symbolizes physical sensation and growth. It represents Mother Earth and fertility. It is the Magician, the Sage, and the Everyman archetypes. Earth is stable, grounding, strong, and protective. It is the realm of wisdom and knowledge, and the womb from which all things grow. This element links to the feminine receptive energy for both men and women. Images and symbols that pertain to earth include:

- **Anchor:** Stability, security, and being grounded; being in tune with yourself.

- **Archangel Uriel:** The keeper of the Earth, wisdom, and prophecy.

- **Bear:** Special powers in healing, wisdom, and strength.

- **Black:** Power, mystery, and shadow games.

- **Brown:** Practicality, earthiness, and grounding.

- **Bull:** Passion, fulfillment, transformation, virility, and strength.

- **Capricorn:** The 10th astrological sign, represents a practical, prudent, disciplined and ambitious nature, as well as carefulness, patience, and reserved humor.

- **Cat:** Independence, feminine/goddess energy, hidden power, mystery, magic, secretiveness, and aloofness.

- **Dog:** Confidence, friendship, protection, loyalty, strength, and courage.

- **Earth Dragon:** Symbolizes potential, riches, and power.

- **Elephant:** Compassion, love, truth, peace, and kindness.

- **Elves:** Life events that have left a mark in your heart.

- **Fox:** Wisdom, trickery, cunning, and quick-thinking.

- **Gargoyle:** Protection, especially from evil.

- **Green:** Healing, peace, nurturing, and new growth.

- **Horse:** Guidance, charm, freedom, free spirit, passion, courage, calmness, and strength.

- **Inverted triangle:** With a horizontal line that goes through the triangle one third up from the bottom point; represents earth.

- **Ivy/vines:** Death, determination, and spiritual growth.

- **Leprechaun:** A mischievous nature; also brings luck.

- **Number 8:** The karmic equalizer, a force that creates and destroys.

- **Panther:** Strength, courage, and independence.

- **Taurus:** The second astrological sign; represents strength, determination, and persistence.

- **Tree of Life:** Immortality, eternity, wisdom, knowledge, abundance, growth, strength and protection.

- **Turtle:** Wisdom; walking our path in peace.

- **Virgo:** The sixth astrological sign, represents a very observant and analytical mind with a tendency to work hard using the most practical methods possible.

- **White lily:** Purity, innocence, and chastity; in other cultures, the trumpet-like flower can symbolize erotic love and procreation.

- **Wolf:** Guardianship, ritual, loyalty, instincts, and spirit; making firm emotional attachments quickly.

Air

Air is equated with wisdom and vital breath. It is the marker of the intellectual and the abstract. It is the Jester, the Lover, and the Outlaw archetypes. Air represents the power of the mind, the force of inspiration, and imagination. It is breath, spirit, freedom, and beginnings. This element symbolizes ideas, knowledge, dreams, and wishes. It is the element of new life and new possibilities. Air links to the masculine energies for both men and women. Images and symbols that relate to air:

- **Archangel Raphael:** The angel of healing.

- **Aquarius:** The 11th astrological sign, represents uniqueness, inventiveness, and the flow of cosmic energy.

- **Bat:** Intuition, vision, and dreams.

- **Butterfly:** Transformation, acceptance, and faith.

- **Dove:** Peace and hope.

- **Dragonfly/Air Dragon:** Embracing change.

- **Eagle:** Wisdom, power, and spirituality.

- **Gemini:** The third astrological sign; conveys a quick wit and a fabulous ability to communicate.

- **Hawk:** Awakens your powers of mystical vision.

- **Heart:** Compassion and understanding, the seat of emotions, healing, and inner wisdom.

- **Hummingbird:** Overcoming obstacles or difficult times.

- **Libra:** The seventh astrological sign, represents harmony, justice, beauty, and peace.

- **Light blue:** Depth, stability, trust, loyalty, and calmness.

- **Number 3:** The connection between the universe and the cosmos; wisdom, consciousness awareness, and power all come from the interplay of the number three.

- **Owl:** Knowledge.

- **Parrot:** A need for freedom or escape; prosperity and abundance; also, the goddess Persephone.

- **Peacock:** Expansive consciousness.

- **Pegasus:** Freedom and assistance in the completion of difficult challenges.

- **Raven:** The good and bad of the self. The archetype and its shadow.

- **Sylph/fairy:** Magic, nature, wisdom, and female energy.

- **Upward triangle:** With a horizontal line that goes through the triangle one third down from the top point, represents air.

- **Wand/magic wand:** Your power and influence over others; moving energy.

- **White:** Purity, innocence, and spirit.

- **Wing:** Love of freedom and movement, remembrance for someone who has passed away, faith, and reminder of the ability to overcome fear and obstacles.

- **Yellow:** Mental alertness, analytical thought, happiness, and optimism.

Water

Water is associated with death and rebirth. It is a healing, purifying element that relates to the Caregiver, the Ruler, and the Innocent archetypes. Water symbolizes psychic intuition and pure love. It is the element of intention and emotions and is symbolic of the subconscious and mystery. Water is the feminine receptive for both men and women. Images and symbols that connect to water:

- **Aqua:** Feminine calming energy, wisdom, serenity, wholeness, emotional balance, tranquility, intuition, and loyalty.

- **Archangel Gabriel:** Inspires artists and communicators.

- **Cactus:** Warmth, endurance, and protection.

- **Cancer:** The fourth astrological sign, conveys nurturing and the ability to sense the emotions in others.

- **Crab:** Self-protection and boundaries; enlightening others on how to treat you.

- **Crown:** Status, pride, and leadership.

- **Dolphin:** Spiritual guidance, intellect, and emotional trust.

- **Frog:** Rebirth, fertility, cleansing, abundance, transformation, ancient wisdom, and life mysteries.

- **Indigo:** Intuition and perception; helpful in opening the third eye.

- **Inverted triangle:** Represents water.

- **Koi fish:** Strength, courage, and creating one's own destiny; can serve as a symbol of rebirth.

- **Mermaid:** Sensuality, femininity, intuition, the moon, and temptation.

- **Moon:** The dark side of nature, the unseen aspect; the spiritual aspect of light in darkness; inner knowledge; the intuitional, irrational, and subjective.

- **Moon phases** represent the infinite process of regeneration and recycling:

 - **Waxing crescent moon:** Birthing ideas or coming up with new projects.

 - **Full moon:** Shares the symbolism of the circle as an image of wholeness and strength.

 - **Half moon:** Energy for moving forward.

 - **Waning crescent moon:** Understanding of consequences, reflection, and a final break from the path untaken.

- **Number 22:** The master number or the builder number on the material plane.

- **Octopus:** Complexity, mystery, illusion, vision, variability, intelligence, and insight.

- **Pisces:** The 12th astrological sign; conveys compassion, mysticism, psychic intuition, and the creative imagination.

- **Scarab:** Heavenly cycle; the idea of rebirth or regeneration.

- **Scorpio:** The eighth astrological sign; represents deep passion, intensity, and the ability to reveal the hidden.

- **Seagull:** Freedom, then dependence.

- **Thunderbird:** Power, divinity, and strength.

- **Trident:** Three-fold essences of nature.

- **Water Dragon:** Brings connection, depth, and passion.

- **Whale:** Intuition and awareness.

Ether

Ether (or spirit) is representative of before birth and after death. Ether relates to unification, transformation, magic, change, alchemy, and divinity. It symbolizes timeless space and infinity, as well as the deep connection with ourselves and even deeper connection with a force of life that is greater than ourselves. It is neither masculine nor feminine, but a projective/receptive energy. Images and symbols that pertain to ether are:

- **Ankh:** Zest and energy; represents both mortal existence and the afterlife.

- **Apple:** Knowledge, immortality, temptation, and sin.

- **Archangel Metatron:** The leader of the Archangels and the Angelic Kingdom, currently holding the role of Multi-Universal Logos (which means he oversees the Multi-Universal Level of the Creator's Universe).

- **Black:** Power, mystery, shadow games.

- **Chameleon:** The ability to perceive the intentions of others.

- **Circle:** Wholeness, eternal life, rebirth, and the life-giving power of the sun; in alchemical symbolism, the circle is a center point of focus.

- **Cloud:** Transformation, mystery, secrets, dreams, intuition, potential, epiphany, and revelation.

- **Compass:** Guidance, the ability to point you in the right direction.

- **Cross:** Suffering, triumph, and victory.

- **Double helix:** Represents the relationship between your natural life (defined as your physical being) and your conscious experience (defined as your life as you know it to be)

- **Ganesh:** A Hindu deity with the head of an elephant and the body of a human that is the Lord of Success and Destroyer of Obstacles, both material and spiritual; also the god of Everyman.

- **Infinity symbol:** Rebirth and reincarnation.

- **Lotus:** Beauty, fertility, prosperity, spirituality, and eternity. The four elements are represented in the lotus: the seed (earth) is awakened by the sun (fire), the flower lives in water and exists in the air. The colors symbolize different meanings:

- **Blue:** Victory of spirit over wisdom.

- **Pink:** Considered to be the true lotus.

- **Purple:** The eight-fold path.

- **Red:** Love and compassion.

- **White:** State of mental purity.

- **Number 1:** The primal being or creation; also symbolizes humankind (reflecting our upright stance)

- **Om symbol:** Represents the state known as *turiya*, or Infinite Consciousness.

- **Planets:** The cosmic elements.

- **Purple:** Wisdom, dignity, grandeur, devotion, peace, mystery, independence, and magic.

- **Sacred geometry:** Reveal each form's vibrational resonances and symbolize the metaphysical idea of the part being related to the whole.

- **Six-pointed star:** Made up of two triangles, one standing upright, the other facing downward; has its origins in the Shiva traditions of South India. The primary purpose of this symbol is to connect the "above" and "below" through the ascension of the powerful energy of *kundalini* (the feminine creative and fertile energy of each cell of the physical body); also represents the Seal of Solomon.

- **Spider:** A weaver; a reminder that our choices construct our lives.

- **Spiral:** Eternity, change, growth.

- **Unicorn:** Purity, magic, and healing.

- **White:** Purity, innocence, and spirit.

The previous lists of suggested tattoo symbols are only a very small sample of the available images you can choose for your personal ink. You can use your inner alchemy and combine the different elemental images to transform the energy held in your subtle bodies. For example, if you want to solve emotional issues you can use a combination of both air and water symbols to pull forth the healing powers of intellect combined with intuitive knowing. The combinations are endless.

The symbols as they relate to the elements and archetypes are also helpful in discerning their effects on the physical body where emotional energy is either stalled or overstimulated. You can initiate an energy shift by consciously choosing symbols that work with the resonance of your body. Always include your intuition because the symbols you embody through tattooing can shape shift their meaning depending on your personal experience and mindset. Everything has both a positive and negative charge, the image and its shadow image, so contemplate your choices carefully. Tattooing can be healing physically, mentally, emotionally, and spiritually *if* you choose to do conscious ink. The intention, symbols, body placement, and colors of your tattoos are the portals for the energy you embody.

Sometimes the right symbol shows up just when there is a need for it. It may be a strictly personal need and can represent an answer to a problem. A tattoo holds its own powerful magic.

The photo on page 147 is an example of how a symbol can represent crossing a threshold, a healing, and self-empowerment. The woman who got this tattoo had gone through a journey to lose a lot of weight. At the completion of her goal, she wanted to have Ganesh, in his role as the remover of obstacles, as a memorial of her success.

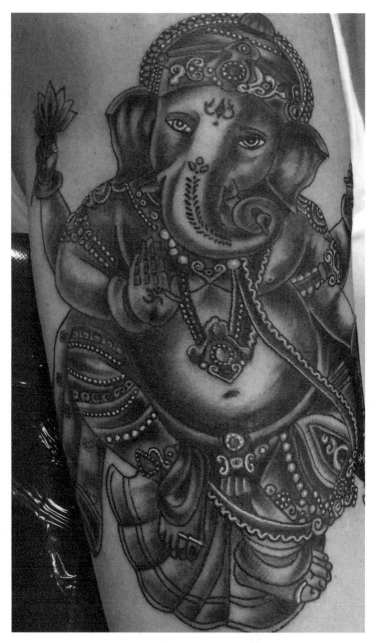

Tattoo by Dave Cutlip.

Symbolic meaning of mandalas

There are some symbols that are tattooed specifically for spiritual healing and for journeying into the self. The mandala is one symbol that many people like to have inked because it represents wholeness. Carl Jung calls the Self the archetype of wholeness. It's the ultimate psychic authority and is beyond all else, including the ego. It is the central source of life and is thus represented through symbols that indicate wholeness or completeness, such as mandalas. Jung perceived that during moments of intense personal growth, the urge to create mandalas emerges.

Edgar Cayce, the famous American mystic known as the Sleeping Prophet, also believed that circular geometric images represent our higher self and viewed the circle as a mandala representing the divine. In many spiritual traditions, the mandala serves as a focal point for meditation and introspection. A mandala symbolizes the universe and expresses a personal striving for unity of the self. It reminds us of our relation to the infinite, the world that extends both beyond and within our bodies and minds.

The word "mandala" means circle and, often, that's what a mandala looks like. Choosing to tattoo a mandala allows you to embody the transformative energy of the mandala and bring yourself into the center of the sacred circle. The center point, the container of your essence, holds the most energy for spiritual awakening and profound healing. There are many different mandala designs relating to varied cultures, but they all share a center point. The different layers expand out from the center and represent the realms of the universe: the spiritual realm, the conscious environment, and the inner wisdom of man. Each of these layers flows into and out of the next as a unified field. The mandala you choose to tattoo should have a special significance for you. Embodying the energy and intention of your mandala tattoo is one aspect of its transformative power, but

ideally it should be placed where you can focus and look at it as way to visually connect with the center point.

Larger mandala tattoos fit better on flatter surfaces of the body because the expanding art is less likely to become distorted. Smaller mandalas are good for other body placements, such as the inner wrist. However, ultimately your consciousness will guide you to the spot on your body where the energy is most beneficial. This makes it a potent tool and a portal for self-exploration. Simply stated, a mandala is a sacred geometric figure made up of symbols that represent the universe. When completed, a mandala becomes a sacred area that serves as a receptacle for deities and a collection point of universal forces.

Following are some of the different mandalas that are often inked as tattoos. Their meaning always holds a deeper spiritual content.

Yantra

A Hindu **yantra** is a geometric design that represents the realm of the spiritual. It is often focused on a specific deity. By tuning into the *yantra*, a connection is made into the deity or particular force centers in the universe. The basis of the *yantra's* potency is held in the "shape energy" or "form energy." Every shape emits a very specific frequency and energy pattern; therefore, the geometric vibrations of a *yantra* make it a powerful symbol for higher resonance to initiate transformation and enlightenment.

A *yantra* is very powerful. Placement must be specifically determined by a true spiritual guru tattooist, because placing this tattoo in the wrong position or upside down can completely change its original purpose and intention.

Yantra tattoos are inked according to the specific moods and emotions of the person getting tattooed. Every emotion is associated with a particular geometric shape representing the forms of the

emotional energy. This unequivocally determines the design of the *yantra* tattoo associated with you and your energy field.

The nucleus of the *yantra* is made up of one or several simple geometric shapes such as dots, lines, triangles, squares, circles, and lotuses representing the subtle energies. For example, the dot (called a *bindu*) signifies the focalized energy and its intense concentration. The dot is usually surrounded by different shapes such as a triangle, a hexagon, or another circle. These forms depend on the characteristic of the deity or desired expression represented by the *yantra*.

The *yantra* usually includes triangles, which are the symbols of energy or aspects of creation. The upward triangle symbolizes intense spiritual desires, while the triangle pointing down represents the feminine sexual organ, the symbol of the supreme source of the universe. The element of fire is always oriented upward, whereas the downward pointing triangle signifies the element of water, which always tends to flow and occupy the lowest possible position.

The intersection of two geometric forms (lines, triangles, circles) represents forces that are even more intense than those generated by the simple forms. For example, two triangles interlocked are more powerful than just one standing alone. There is a high level of resonance in the dynamic interaction of the corresponding energies. The empty spaces generated by such combinations are described as very efficient operational fields of the combined forces emanating from the central point of the *yantra*.

A typical combination often found in the graphical structure of a *yantra* is the interlocking of two triangles, one pointing upward and the other downward, forming a star with six points, also known as a hexagram. The circle is often used in *yantras* to represent rotation, a movement closely linked to the shape of a spiral that is fundamental in the macrocosmic evolution. The circle also represents

perfection and the mystical, creative void. Aside from the triangle and circle, *yantras* also include the square. The square is usually the exterior limit of the *yantra* and represents the element earth. Every *yantra* starts from the center, often marked by the *bindu* and ends with the outer square. This represents the function of universal evolution, which starts from the subtle energy, ether, and ends with the dense energy, earth.

Most of the time, *yantras* are composed of simple geometric shapes, but they can also include other things in the design such as swords, arrow points, tridents, or other elements for the trajectory and directions of action for the *yantra's* energies. One example of this is the lotus flower. The petals typically represent chakras, with each petal corresponding to a distinct psychic propensity associated with that chakra. The inclusion of a lotus in a *yantra* represents the unfolding of awareness.

Symbols incorporated into the *yantra* include:

- **Swords, arrow points, tridents:** Trajectory and directions of energies.

 - **The downward pointing triangle:** The feminine sexual organ and the element of water.

 - **The upward pointing triangle:** Signifies intense spiritual aspiration and the aspects of creation, the element of fire.

- **The circle:** Rotation, a movement, perfection, and the mystical creative void.

- **The dot (*bindu*):** Signifies the focalized energy.

- **The intersection of geometric forms:** Forces that are even more intense than those generated by the simple forms.

- **The lotus flower:** Unfolding of awareness.

- **The lotus petals:** Each corresponds to a distinct psychic propensity associated with a chakra.

- **The square:** Represents the earth element.

Dreamcatcher and medicine wheel

The dreamcatcher and medicine wheel are Native American mandalas, both of which are circular in shape. The circle has always been an important symbol to the Native Americans. It represents the sun, the moon, the cycles of the seasons, and the cycle of life from death to rebirth.

Dreamcatchers have been a part of Native American culture for generations. Within the circle, there is what appears to be spider webs (usually made out of sinew, or strong but thin string). The web is meant to catch any bad dreams a sleeping child may have. The center of the dreamcatcher has a center hole and a small bead, which is representative of a spider. Spiders are symbolic of the feminine creative energy and patience. The single bead also shows that there is only one, true creator in the web of life.

The dreamcatcher rim is usually decorated with sacred items such as feathers and beads. The feathers are symbolic of breath and air, which are essential for life. Native Americans believe that the night air is filled with both good and bad dreams. Dreamcatchers are hung near the bed of a sleeping child; they let the good dreams pass, slipping through the center hole, to gently slide down the feathers into the sleeping child's dreamtime. Bad dreams get tangled in the dreamcatcher and perish with the first light of the new day.

Dreams are the door into the subconscious, and many times reveal hidden knowledge through dream symbols. The dreamcatcher

symbolically represents how to be open to the messages of our dreams and how to discern and organize the information as needed. We travel in the imaginal dimensions when we dream. Dreams take us into the realm of the transpersonal and can connect us to living energies beyond our own.

Dreams hold soul knowledge. In fact, your dreamtime is perhaps your most powerful time for true soul work. Ancient peoples have understood that dreaming is actually a form of traveling. You can visit other realms. You can meet teachers. You can connect with the deceased and receive guidance from evolved beings. The dreamtime can be a portal to connect with archetypes and even glimpse the future. Dreams can be a transformational path connecting you with the full spectrum of who you are so you can bring wisdom back to your waking world. Dreams have so much healing energy and information to offer. They hold vast potential for transforming your life. You can become a shaman of your own soul and healer of your own life.

The dreamcatcher as a tattoo symbolically represents a connection into the subconscious. It reminds us to filter negative emotions and to be aware of the importance of dreamtime. A breakdown of the components of the dreamcatcher and what they mean:

- **Bead:** Represents a spider, which is symbolic of the feminine creative energy and patience.

- **Circle:** Symbolizes wholeness.

- **Feathers:** Represent air, which is associated with the power of the mind, the force of inspiration, and imagination; it is breath, spirit, freedom, and beginnings.

- **Web:** Reminds us that we create many of the situations in our lives.

The **medicine wheel** signifies the natural cycles of life. It is a universal symbol, and its meaning has been defined by different cultures throughout the ages based on their location, religious beliefs, and tribal practices. The medicine wheel is a circle separated by a cross, thus forming four quadrants. The center point of the interior cross is symbolic of our connectedness to each other, nature, and spirit. The circle represents the continuity of the cycle of life for all living beings, human and non-human, showing all things are connected and equal because, in a circle, there is no beginning and no end.

The medicine wheel as a tool can give great depth and insights into our relationships with nature, spirit, ourselves, and others. It is representative of all our relations and creations, or "all things." This is a profound concept. "All things" does not just encompass matter alone, but also spirit. Every word ever spoken, thought that has been thought, act that has been done, and path that has been walked are still rippling out from their originating source and will continue forever, just as the circle continues around forever.

The four quadrants themselves represent more than one concept: the phases of life (childhood, adolescence, adulthood, elder years), the elements, (fire, water, air, earth), the seasons (spring, summer, fall, winter), the cardinal directions (north, south, east, and west), and aspects of consciousness (mental, emotional, spiritual, physical).

Aside from the four quadrants, the wheel can also be said to represent seven directions. As a three-dimensional sphere, there is also the "up to the sky" direction, the "down to earth" direction, and the center direction, which is viewed as the location within the individual or the axis mundi connecting the opposing aspects of the cosmos and consciousness. The power of birth, death, and rebirth are

encompassed in the medicine wheel, as well as everyone's own path toward personal growth and realization.

Each quadrant of the circle is a different color, black, white, yellow, and red. Layout of the wheel varies across tribes and even individuals as they journey through life. The quadrants and their associations are:

- **East** is yellow, spring, the fire element, tobacco (the plant), awareness, and how we resolve with spirit.

- **North** is white, air, winter, sage (the plant), wisdom, and how to receive with the mind.

- **West** is black, earth, autumn, sweetgrass (the plant), knowledge, and how to hold within the body.

- **South** is red, the element of water, summer, cedar (the tree), understanding, and how to give with the emotions.

The colors can also have alternate meanings depending on the tribe they are associated with, but the basic principle is the same: the importance of appreciating and respecting the ongoing interconnectedness and interrelatedness of all things. Therefore, there is no right or wrong way of representing or using medicine wheels. They all hold meaning to the various indigenous nations.

As a tattoo, the medicine wheel helps one embody balance and a connectedness to "All Things." When a person is dominated excessively by a certain force, energy, or attitude, it will cause an imbalance. It can be symbolic of your spirituality and of your unique, individual way of finding your path, a journey of truth, harmony, and peace. It is the symbol of the wheel of life, a never-ending circle, forever evolving and bringing new lessons.

Animal symbols incorporated in the medicine wheel are:

- **Bear:** Symbolizes the west point on the medicine wheel, the color black, and the season of fall; it represents strength, confidence, and quiet time.

- **Buffalo and wolf:** Symbolize the north point on the medicine wheel, the color white, and the winter season; the buffalo represents abundance, strength, gratitude, and freedom; the wolf signifies sharp intelligence and instincts.

- **Eagle:** Symbolizes the east point on the medicine wheel, the color yellow, and the spring season; the eagle stands for courage, wisdom, strength, illumination, and clarity regarding your life path.

- **Coyote and mouse:** Symbolize the south point on the medicine wheel, the color red, and summer; the coyote represents the trickster, shape shifter, adaptation, creativity, wisdom, and intuitiveness; the mouse is associated with instincts, observation, gathering, and timing.

- **Butterfly:** Symbolizes the center point on the medicine wheel, the colors of the rainbow; it's representative of transformation and healing, and signifies a dimensional traveler.

Celtic symbols

Celtic mandalas open the portal to embody the qualities associated with these ancient images. There has been a resurgence of interest in all things Celtic, especially Celtic symbol tattoos. Celtic tattoos may even be considered tribal tattoos. Many people choose to ink them as armbands, ankle tattoos, or even as a design on the back of the neck or on the chest close to the heart.

The Celts were an extremely spiritual people who found deep symbolism in nature. Even the elemental and ordinary things in life had a mystical significance to the Celtic people. The ancient Celts believed their symbols and signs held amazing and meaningful powers that could influence their lives. They believed they could intimately communicate with spirits and advanced their intuition by focusing on symbols that held deep meaning and mystical beliefs.

Celtic mandalas have the common theme of a circle. For the Celts, it was the circle of life, death, and rebirth. The Celts believed in an immortal soul, and that death was the passage into the Otherworld, a world parallel and similar to this one. After a time in the Otherworld, a person would be reborn into this one, and so the cycle of life, death, and rebirth would continue.

The Celts also believed wisdom resided in the earth, trees, rocks, and streams, as well as in animals. They all held memory of what was important to the tribe. The Celtic mystical tradition emphasized the direct knowledge of God through the natural world. (Like other spiritually inclined groups, they practiced shamanism.) Their art style was very distinctive, incorporating swirling curves and abstract shapes in geometric designs. All Celtic mandalas contain a center point composed of meaningful Celtic symbols contained inside an outer circle.

The Celts seem to have inherited a special appreciation for the number three from their Indo-European ancestors, an appreciation shared by many other cultures. The Greek mathematician Pythagoras, for example, called three the perfect number, as it is symbolic of harmony and completion, allowing for beginning, middle, and end. Medieval Celts often expressed forms of triplism in their religion and literature. Some of the most popular Celtic

mandalas inked as tattoos incorporate the number three into their designs.

The *triquetra*, or **trinity knot**, is an ancient Celtic symbol comprised of one interconnected line with three distinct ends. This design demonstrates the three-in-one of the Father, Son, and Holy Spirit. The trinity knot is often circumscribed by a circle symbolizing eternity. Pagans, who are present-day offshoots of the original Celts/Druids, have an earthier view to the symbolism, seeing it as a representation of earth, air, and water. On a more spiritual level, it has also been known to symbolize life, death, and rebirth. Basically, all meanings come down to one thing: three distinct entities that are interconnected.

The **Celtic spiral** is an ancient symbol that represents three factors: continuous growth, unity, and oneness of spirit. The spiral may be formed from single, double, or triple swirls, and the gaps between the spirals stand for the gaps between life, death, and rebirth. The double spiral means the transference of energy from the body to the soul, or the body giving life back into the earth, which is a popular theme in Celtic symbolism.

The *triskele* or **triple spiral** is an ancient Celtic symbol signifying reincarnation and a continuous movement of time. The Celts believed the most important things in life came in threes (birth, death, and rebirth; body, mind, and spirit; earth, water, and sky; past, present, and future; Father, Son, and Holy Spirit). It was associated with the Triple Goddess (maiden, mother, and crone) in pre-Christian times. Sometimes it is drawn in one continuous line to represent a continuous movement of time. Some of the more current interpretations of the *triskele* are of life, personal growth, and spiritual expansion.

The **Celtic Tree of Life** can be interpreted in many ways. The balance and harmony prevalent in nature is best symbolized by the

Tree of Life. The Celtic Tree of Life symbolizes wisdom, strength, and longevity. The Druids believed the gods communicated with humans through trees because some of these trees were capable of carrying messages to the Otherworld. The Tree of Life is the symbol of a presence that connects the upper and lower worlds:

- **The roots** reach the depths of the lower world, the subconscious.

- **The branches** grow upward toward the upper worlds, the higher mind.

- **The trunk** remains in the middle world, the earth's plane, everyday reality.

The Tree of Life is often centered within a circle of Celtic knots, also known as endless or mystic knots that do not have a beginning or end. The designs of Celtic knots are characterized by roots and branches interwoven to form an endless knot. This circular design of knots symbolizes eternity or timelessness of nature.

The **Celtic cross** is a popular symbol throughout Ireland. Its true history has pagan roots but the contemporary symbolic reference associates it with Christian beliefs. The cross is a universal symbol and exists in all cultures, as does the circle. The circle is eternal, and the cross both reaches out and marks a specific point at the center.

The Celtic cross's pagan roots are apparent in its design. The ancient Druids worshiped the sun and moon, as they were important symbols to them. Universally, a plain circle is often a symbol for the moon; a cross within a circle, or the arms of a cross extending beyond the circle, are traditionally symbols for the sun. The cross by itself also relates to other ideas such as the four directions (north, south, east, and west) and the four elements (fire, water, air, and earth). The circle, or the ring in the middle of the Celtic cross, is a

symbol for infinity and eternal spiritual love, although some believe it to represent the Druid sun god, Lug (Loo).

As mandalas, Celtic cross designs usually have the cross in the center encased in a circle of Celtic knot work, loops, and mazes. The knots symbolize the link between the physical and the spiritual life, while the loops symbolize the never-ending circle of life. The meaning of the number three can be seem in the Celtic cross, symbolized by the horizontal part of the cross (the world), the vertical portion (heaven), and the ring in the middle (unification of heaven and Earth).

Wiccan mandalas

Wiccan mandalas reflect the neo-pagan belief system, Wicca, which centers on nature worship. (It is not to be confused with devil worship.) Wiccan beliefs exist without any structured clergy or congregations, although there are priests and priestesses in leadership positions. Wicca honors a Triple Goddess (related to the moon, Earth, and sea; maiden, mother, and crone), as well as a Horned God (related to the sun, animals, and forests).

To Wiccans, the circle symbolizes the cosmos and the feminine spirit. It represents wholeness, unity, and infinity, and also inspires other symbols like the Spiral of Life, Circle of Earth, and Wheel of the Year. Because they believe in the power of circles, Wiccans gather within them for performing spells, rituals, and celebrations.

Wiccan symbol tattoos are popular. They are inked as a way to signify the rite of passage and to also embody the energies and power of the deities symbolically represented by the tattoo image. Some of the more prominent symbols used for mandalas and tattoos are the pentagram, pentacle, triple moon, and Wheel of the Year.

The **pentagram** is the most powerful symbol of all ceremonial rites. It is a five-pointed star that represents the five elements (four

elements of material creation surmounted by the fifth element of spirit). It is also the symbol of the perfected human being. Each of the points of the pentagram relates to a particular element and its corresponding nature. Starting from the top point that represents spirit, the elements move clockwise on each point as follows:

- **Spirit** symbolizes *to become perfected*. It represents the mystical aspect of Wicca.

- **Water** symbolizes *to dare*. It relates to that which unites and binds us to others and to the universe around us. Water represents the spiritual element of Wicca.

- **Fire** symbolizes *to will*. It relates to energy, will, and passion. In Wicca, fire enhances magical powers.

- **Earth** symbolizes *to learn*. It relates to the practical knowledge of the Wise Woman and Knowing Man.

- **Air** symbolizes *to keep silent*. It relates to the mind, intellect, words, thoughts, philosophy, and ideas.

The pentagram can be used in meditation and for self-discovery. The way the pentagram is positioned can change its meaning. If a single point is upward, it signifies summer and the spirit ruling over matter, and is a symbol rightness. When reversed, it signifies winter and subservience, with emphasis on the carnal nature of man.

The **pentacle** is a pentagram enclosed in a circle signifying wholeness, the elements, and our ultimate unity with nature. Both the pentagram and the pentacle are two of the most powerful symbols in the world of Wicca. As a tattoo, it is a very protective symbol.

The **Triple Moon symbol**, sometimes called the **Triple Goddess symbol**, relates to the lunar cycle, with the moon in three phases: waxing, full, and waning. First, there is a crescent moon in a growing/waxing phase. In the center, a circle symbolic of the full moon.

Lastly, there is a crescent denoting the diminishing/waning moon. It also is viewed symbolically as the moon, earth, and sea, as they express the feminine instinct, mother, and life. The Triple Moon relates to aspects of the divine feminine: creative energy, intuition, and wisdom and mystery. It also indicates the three life stages of a woman, and in its entirety, the symbol conveys the eternal cycle of birth, life, and rebirth. As a tattoo, the Triple Moon symbol is a portal to embody the energies associated with the symbol, and can also denote a woman as a priestess.

Sometimes the center circle or full moon encases an image such as the pentagram, the Tree of Life, the trinity knot, or an image for a specific goddess deity. The images within the center/full moon are often used as a focal point for working with a triple moon mandala:

- The **waxing moon** represents the Maiden. It relates to purity, youth, new life, rejuvenation, enchantment, and expansion.

- The **full moon** represents the Mother. It relates to fulfillment, fertility, potency, compassion, giving, nurturing, protection, and power.

- The **waning moon** represents the Crone. It relates to maturity, wisdom, experience, knowledge, death, and rebirth.

The **Wheel of the Year** signifies the annual cycle of the Earth's seasons. It consists of eight festivals, referred to by Wiccans as *sabbats*, holidays based on the major solar and lunar events. The passing of time is also seen as cyclical and is represented by a circle or wheel. The progression of birth, life, decline, and death, as experienced in human lives, is echoed in the furtherance of the seasons. The Wheel of the Year is symbolized by a circle containing a center point from which eight spokes radiate outward. The center point sometimes holds an image of a pentagram, the sun, the Triple Goddess, or the

triskele. The eight sabbats begin with Samhain and move clockwise around the wheel, moving onto Yule, Imbolc, Ostara, Beltane, Litha, Lammas, and Mabon.

Samhain, also known as Halloween, is considered by most Wiccans to be the most important of the four greater sabbats. Samhain is a time to celebrate the lives of those who have passed on. It is seen as a festival of darkness, which is balanced at the opposite point of the wheel by the spring festival of Beltane, which Wiccans celebrate as a festival of light and fertility.

Symbols for Samhain (October 31 to November 2) include:

- **Black cat:** Protection in the astral world.

- **Skull:** Reminds us that life and death are both part of our immortal soul's journey.

- **Spider:** Represents the intricate meaning to life; medieval superstition said that if you saw a spider on Halloween, it was the spirit of a dead loved one watching you.

Yule is a lesser sabbat, also known as midwinter or the winter solstice. Yule is when the dark half of the year relinquishes to the light half. It is the rebirth of the Great God, viewed as the newborn solstice sun. Also known as solstice night, or the longest night of the year, much celebration is to be had as the Goddess gives birth to the Oak King or the Sun King.

Symbols for Yule (December 19 to 23) include:

- **Isis:** The goddess of fertility, rebirth and magic.

- **Elf:** Represent the long-lived or immortal; also associated with life events that have left a mark in your heart.

- **Sun Wheel:** An equal-armed cross within a circle invokes the great cosmic powers to bless the Earth with fertility, life, abundance, prosperity and peace.

Imbolc is a greater sabbat, also called Candlemas, is the period for initiations, rededication, and pledges for the coming year. This holiday is sacred to the Celtic fire goddess Brigit, patron of healing, midwifery, and poetry. It is also the festival of the maiden and begins her season to prepare for growth and renewal.

Symbols for Imbolc (February 1 and 2) include:

- **Brigit's Cross:** The life-giving goddess, and the beginning of spring; Brigit is also associated with fire

- **White flowers:** Purity and innocence.

- **Violets:** Delicate love, modesty, intuition, nobility, dignity, and faith.

Ostara is a lesser sabbat, also known as the spring/vernal equinox. This festival celebrates the rejoining of the Mother Goddess and her lover/consort/son, who spent the winter in death. Other commemorations include the young god regaining strength and the Goddess returning to her maiden aspect.

Symbols for Ostara (March 20 to 23) include:

- **Triple Goddess:** The aspects of Maiden, Mother, and Crone.

- **Green Man:** The eternally growing and self-renewing energy of nature.

- **Ouroboros (Serpent Dragon):** The symbol of a snake eating its own tail, an eternal cycle of renewal.

Beltane, also recognized as May Eve or May Day, is a greater sabbat. It is celebrated as an early pastoral festival, with rituals held to promote fertility. On this day, a rowan branch is hung over the

house fire to preserve it from bewitchment. The myths of Beltane include that of the young god blossoming into manhood and courting the goddess. Through their union, all life begins.

Symbols for Beltane (May 1) include:

- **Stag/antlers:** Masculine virility, fertility, power, and strength.

- **Fairies:** They are elementals and represent the major divisions: air, earth, fire, and water.

- **Sword:** Strength, decisiveness, ambition, competitive nature, and willpower.

- **Arrow:** Movement and the male sex.

Litha, or midsummer, is a lesser sabbat. Also known as summer solstice, it is considered the turning point at which summer reaches its height and the sun shines longest. Litha is the most powerful day of the year for the Sun God. Fire plays an important role in this festival.

Symbols for Litha (June 19 to 23) include:

- **Salamander:** Energy, determination, renewal, courage, and solar symbolism.

- **Rose:** The five-petaled rose represents beauty, joy, and the physical pleasure of life on Earth.

- **Sun:** Vitality, knowledge, courage, and energy.

Lammas, or Lughnasadh, is a greater sabbat of the harvest and is the first of the three autumn harvest festivals (the other two being the autumn equinox and Samhain). It celebrates the first fruits of harvest and the unfolding of desires that we had at the start of the year. The god wanes in power at Lammas.

Symbols for Lammas (August 1 and 2) include:

- **Full moon:** Shares the symbolism of the circle as an image of wholeness and strength; a time for the recognition of the goddess in her phase as mother.

- **Sunflower:** Vitality, energy, and fertility; also represent the high point of the sun's presence, and the dusk of its declining influence; one of the Summer Lord's emblems.

- **Pentacle:** Wholeness, the elements, and our unity with nature.

Mabon is a lesser sabbat, also known as the autumn equinox. It marks the middle of harvest, and is a time of equal day and equal night, when nature is in balance. It is a time of giving thanks for the harvest. Mabon is the time to look back on the past year and on your life, as well as plan for the future. The Sun God journeys into the lands of winter and passes into the underworld at Samhain, then is once again born from the goddess at Yule.

Symbols for Mabon (September 19 to 21) include:

- **Acorn:** They can grow into a massive oak tree; their dormant state are a reminder that we need periods of rest and periods of growth.

- **Vines/ivy:** Perennial life and immortality, a symbol of death, determination, and spiritual growth.

- **Solomon's Seal (plant):** A return year after year.

- **Apple:** Knowledge, immortality, temptation, and sin.

The Wheel of the Year symbol as either a tattoo or a mandala for meditation brings one to focus on the never-ending cycle of life. It is rich in symbolism and representative of our connectedness to nature.

Astrology wheel

An **astrology wheel**, or **astrology chart**, is in itself a mandala showing the cycles of life, growth, and transformation. Astrology tattoos are some of the most popular symbols inked. These symbols carry deep meaning for embodying the archetypes they represent, along with the elements of nature and their associated qualities. The planets and stars intertwine with the matrix of your body, mind, and spirit to bring about a higher awareness to your consciousness, that mysterious aspect essential to human existence.

Your astrological chart is your personal mandala that gives an illuminating look at your psyche and your relationship to the universe. It is an ancient science that helps man to decipher his life's purpose, and can be used as a personal system for information and wisdom. Astrology has a long tradition of use in ancient Greek medicine, as well as in other traditional healing systems like *ayurveda*, which is based on the guiding principle of "As above, so below; as within, so without." In other words, the microcosm of the human body reflects the macrocosm of nature and the cosmos.

Though you are born under a certain sun sign, your personal astrology chart is a moving mandala because the shifting of the planets coincides with experiences, growth, and the cycles of life. Your astrology chart mandala furnishes insight into the planetary movements that indicate the nature, meaning, and duration of various developmental periods and gives insight into the best way to navigate the challenges and opportunities that may be presented during your current incarnation.

An astrology chart mandala begins with two circles, each divided into 12 sections. The outer circle is the zodiac wheel; the inner circle represents the Earth and the coordinates, or exact location, of your birth place. The 12 sections represent the 12 signs of the zodiac. Each section in the circle (called a house) represents a different

area and specific function of your life. The planets are arranged on the zodiac wheel according to their actual astronomical position and represent a map of the heavens at the moment you were born. You are the center point of the astrology chart.

Sun signs all have a nature described as masculine or feminine, which has nothing to do with sex. **Masculine signs** are outgoing and interested in what is going on around them. **Feminine signs** are more inwardly directed.

Each astrological sign also has a nature such as cardinal, mutable, or fixed:

- **Cardinal signs** are action-oriented.

- **Mutable signs** are changeable.

- **Fixed signs** are stubborn.

Each astrological sign has an element that represents one of the energies of life:

- **Fire signs** are quick and impulsive.

- **Air signs** are intellectual.

- **Earth signs** are practical.

- **Water signs** are emotional.

Your sun sign represents the soul lesson of your life, the real and most fundamental reason behind your incarnation. If you wish to know why a soul has incarnated, in general and basic terms, the sun is the body that will tell you. Your sun sign signifies your main archetype, your creative force, and how you approach the world around you.

Aries (March 21 to April 19), the first sun sign of the zodiac, is a masculine fire sign and cardinal in nature. The sun in Aries is active,

energetic, adventurous, passionate, cheerful, impatient, and at times argumentative.

- **Symbol: Ram.** Like the ram, Aries is extraordinarily aggressive and self-willed, as well as headstrong, excitable, and impulsive.

- **Ruling planet: Mars.** This is a planet that pulses with the vibrations of energy and action.

- **Archetype: Hero.** Aries finds their shadow in the sign of Libra.

- **Color: Red.** It symbolizes life force, sex, survival instinct, passion, anger, anxiety, and nervousness.

Taurus (April 20 to May 20), the second sun sign of the zodiac, is a feminine earth sign, and fixed in nature. The sun in Taurus is romantic, decisive, logical, and diligent, but also stubborn.

- **Symbol: Bull.** Like the bull, Taurus will only charge when provoked, and prefers to keep a calm abode where they can peacefully relax undisturbed.

- **Ruling planet: Venus (dark side).** The sultry side of Venus is more in tune with the pleasures and desires for the material world.

- **Archetype: Magician/Enchantress.** Taurus finds their shadow side in the sign of Scorpio.

- **Color: Green.** It symbolizes healing, peace, nurturing, and new growth.

Gemini (May 21 to June 21), the third sun sign of the zodiac, is a masculine air sign and mutable in nature. The sun in Gemini is very changeable and adaptable, but can also seem indifferent.

- **Symbol: Twins.** The twins symbolize a duality to their nature, a double bodied sign, showing they are great

conversationalists and very social, but can be a bit removed at the same time.

- **Ruling planet: Mercury (light side).** The day side of Mercury, rules fun, communication, mental alertness, analytical thought, happiness, and optimism.

- **Archetype: The Jester.** Gemini finds their shadow side in the sign of Sagittarius.

- **Color: Yellow.** It symbolizes mental alertness, analytical thought, happiness, and optimism.

Cancer (June 22 to July 22), the fourth sun sign of the zodiac, is a feminine water sign and cardinal in nature. The sun in Cancer is intuitive, imaginative, dedicated, and caring, but also very sensitive:

- **Symbol: Crab.** Like the crab, Cancer may present a tough exterior but inside they are extremely soft and easily hurt.

- **Ruling satellite: Moon.** Like the moon, Cancer is very changeable, from bright and happy to dark and moody. The moon allows Cancer to tend to lead with their feelings.

- **Archetype: Caregiver.** Cancer finds their shadow side in the sign of Capricorn.

- **Color: White.** It symbolizes purity, innocence, and spirit.

Leo (July 23 to August 22), the fifth sun sign of the zodiac, is a masculine fire sign and fixed in nature. The sun in Leo is loyal and enthusiastic, as well as creative and charismatic. Leo will persevere and defend their position until the end, but can also be arrogant.

- **Symbol: Lion.** In keeping with the nature of this regal animal, Leos execute most of what they do with pride, dignity, and enthusiasm.

- **Ruling Star: The Sun.** This bestows upon Leo creativity and a love for drama. It also gives this sign a passionate and direct nature in their communications and behavior.

- **Archetype: Creator.** Leo finds their shadow side in the sign of Aquarius.

- **Color: Orange.** It symbolizes sensuality, physical pleasure, emotional self-expression, and creativity.

Virgo (August 23 to September 22), the sixth sun sign of the zodiac, is a feminine earth sign and mutable in nature. The sun in Virgo is modest, practical, and clearheaded but also a bit fussy.

- **Symbol: The Virgin.** The virgin maiden carrying wheat in one hand and a caduceus in the other represents someone capable of standing alone; also, many Virgos are health-conscious even if they are not involved in any traditional medical professions.

- **Ruling planet: Mercury (dark side).** The night side of Mercury makes for a fussier, over-analytical type with physical restlessness and nervous energy.

- **Archetype: Sage.** Virgo finds their shadow side in the sign of Pisces.

- **Color: Brown.** It symbolizes practicality, earthiness, and grounding

Libra (September 23 to October 23), the seventh sun sign of the zodiac, is a masculine air sign and cardinal in nature. The

sun in Libra is idealistic, equitable, just, and charming, but also indecisive.

- **Symbol: Scales.** The scales signify how Libra weighs, assesses, and compares options.

- **Ruling planet: Venus (light side).** Here we find the day side of Venus, which rules relationships based on the deeper meanings of love.

- **Archetype: Lover.** Libra finds their shadow side in the sign of Aries.

- **Color: Light blue.** It symbolizes depth, stability, trust, loyalty, and calmness.

Scorpio (October 24 to November 22), the eighth sun sign of the zodiac, is a feminine water sign and fixed in nature. The sun in Scorpio gives a strong determination, sometimes verging on ruthlessness, when intently focused on achievement.

- **Symbol: Scorpion.** Scorpio was formerly represented by the eagle and the phoenix; they can lay low like the scorpion, strike like an eagle, and possess the uncanny ability to rise from the ashes like the phoenix just when you think they have been defeated.

- **Ruling planet: Pluto.** This planet brings a burning intensity and resolute determination.

- **Archetype: Ruler.** Scorpio finds their shadow side in the sign of Taurus.

- **Color: Indigo.** It symbolizes intuition and perception, and is helpful in opening the third eye.

Sagittarius (November 23 to December 21), the ninth sun sign of the zodiac, is a masculine fire sign and mutable in nature. The sun

in Sagittarius is insightful, rational, brave, and optimistic, but can also be careless.

- **Symbol: The Archer.** Sagittarius is double-bodied sign being made up of half man and half horse; a centaur drawing a bow. There is a restlessness because of the duality of their nature.

- **Ruling planet: Jupiter.** A planet that likes things done in a big way, it bestows friendliness, optimism, and a sense of humor, but also exaggeration and bluntness.

- **Archetype: Explorer.** Sagittarius finds their shadow side in the sign of Gemini.

- **Color: Purple.** It symbolizes extravagance, wisdom, devotion, and independence.

Capricorn (December 22 to January 19), the 10th sun sign of the zodiac, is a feminine earth sign and cardinal in nature. The sun in Capricorn is intelligent, practical, reliable, generous, optimistic, and persistent, but can also be stubborn and suspicious.

- **Symbol: Goat.** The goat represents steadiness and ambition; sometimes Capricorn is represented by the sea goat, signifying man as a spiritual being having an earthly experience.

- **Ruling planet: Saturn.** This planetary energy imparts a serious outlook, with a philosophy that nothing can be won without hard work.

- **Archetype: Everyman.** Capricorn finds their shadow in the sign of Cancer.

- **Color: Black.** It symbolizes power, mystery, and shadow games.

Aquarius (January 20 to February 18), the 11th sun sign of the zodiac, is a masculine air sign and fixed in nature. The sun in Aquarius is original, ideal, independent, and inventive, but can also be rebellious.

- **Symbol: Water bearer.** This symbolizes the cleansing and pouring fourth of consciousness.

- **Ruling planet: Uranus.** This planet bestows innovative thinking, heightened intuition, and great communication skills.

- **Archetype: Outlaw.** Aquarius finds their shadow side in the sign of Leo.

- **Color: Turquoise.** It symbolizes energy, wisdom, serenity, emotional balance, friendship, intuition, and loyalty.

Pisces (February 19 to March 20), the 12th sun sign of the zodiac, is a feminine water sign and mutable in nature. The sun in Pisces is intuitive, creative, imaginative, and caring, but can also be elusive and changeable:

- **Symbol: The Fish.** Pisces is a double-bodied sign represented by two fish swimming in opposite directions; the duality of Pisces, as indicated by their symbol, shows the light and dark side to their nature.

- **Ruling planet: Neptune.** This ethereal and mystical planet gives a penchant for the arts, a gracious disposition, and a profoundly well-developed psychic sense.

- **Archetype: The Innocent.** Pisces finds their shadow side in Virgo.

- **Color: Aqua.** It symbolizes calming energy, wisdom, serenity, wholeness, emotional balance, tranquility, intuition, and loyalty.

Astrology is full of symbolism. The esoteric aspects of astrology focus on consciousness and the soul. The soul-centered perspective zeroes in on the purpose of the soul, why we are here, where we have come from, and where we are heading. Understanding the symbolism of the elements, along with the symbolism of the planets and archetypes, takes you beyond the mere aspects of the personality and puts the focus on truly understanding your soul's purpose. Astrology symbol tattoos represented by either the sign's glyph, image, planet, or element, allows you to embody the full essence of your sun sign. You can enhance the efficacy of the symbol by choosing to ink it in your Sun sign's power color.

Chakra symbols

Chakra symbols act as portals for rejuvenating energy to enter and balance your subtle body system. Chakra mandalas are very popular tattoos. Aside from the beautiful imagery, there is also a very strong healing power associated with these images.

Chakras are the main energy hubs in the human energy field. They are shaped like circles or petals, and lay across seven points on your spinal column, from the base of the spine to the top of the head. Chakras are perceived as whirling, wheel-like energy that flows into and out of a person. There are seven major chakras, plus many minor ones positioned on the body. Each chakra corresponds to specific emotions, colors, body parts, and a particular psychic sense. You can find a more in-depth look at the chakras in Chapter 2.

Every chakra has a distinct symbol associated with it. If you're trying to heal, support, or cultivate a particular chakra, you can tattoo the symbol for that chakra on you. The symbolism for each chakra center has a deep and complex meaning. These symbols hold an image and color that specifically resonates with a particular chakra. The energy that these chakra symbols impart expands far beyond our intellectual understanding.

The ultimate goal of any chakra tattoo image is to help you release old patterns that serve you no purpose so you can rebalance and integrate more refined energies into your body, mind, and spirit. Some of you may wonder if the chakra tattoo has to be placed right on the specified chakra. When you consciously tattoo, the body will call for the symbol and its needed placement. For instance, a certain chakra center may need assistance from another center in order to become more fully balanced. Chakras along the spine also radiate through to the front of your body. Listen to your inner guidance when determining placement for your tattoo.

First chakra, root (base of spine): This symbol is made up of four red lotus petals and a square with a downward-facing triangle. The triangle is a symbol of spirit connecting with matter. It's seen as the center of our vital life force and is the seat where *kundalini,* our primordial mystic fire, stays coiled and dormant until it wakes up to distribute its energy through all the other chakras. The square represents the field of matter. This chakra relates to the earth element. Its true purpose is to feel safe and secure, to manifest basic needs, and to experience belonging.

Second chakra, sacral (lower abdomen): This symbol is made up of six orange lotus petals and a circle containing a crescent moon. The circle represents water. The crescent moon, colored in white or silver, represents the connection of the energy of the moon with water. It symbolizes the relationship between the phases of the moon and the fluctuations in water and emotions. This chakra relates to the water element. Its true purpose is to bond our emotions with those of others without losing our identity, as well as to have freedom of creativity.

Third chakra, solar plexus (upper abdomen): This symbol is made up of 10 yellow lotus petals and a circle containing a red downward facing triangle. The downward pointing tip of the triangle symbolizes the origin, and the upward spreading sides of the

triangle indicate growth and development. The inverted triangle is a symbol for the flame of this chakra that expands and rises upward. Fire turns matter into energy that can be used to move us forward. The circle contains that energy. This chakra relates to the fire element. Its true purpose is to trust inner guidance, stand in one's own power, and release the need to control others.

Fourth chakra, heart (center chest): This symbol is made up of 12 green lotus petals and a circle containing two intersecting triangles that form a six-pointed star (hexagram). One triangle symbolizes the movement of matter up toward liberation, and the other represents the spirit moving down into manifestation. They also symbolize the union of male and female, as well as the emphasizing the heart chakra as a center of integration and connection. The circle represents the field of emotions. This is the bridge between the lower chakras and the upper chakra centers. This chakra relates to the air element. Its true purpose is to experience compassion and connection with the self and others.

Fifth chakra, throat: This symbol is made up of 16 blue lotus petals and a downward-facing triangle containing a circle. The inverted triangle is a symbol of spiritual growth; the downward-facing orientation represents the gathering of information, and the expanding upward sides represent broadening knowledge and enlightenment. The circle represents the self. This chakra relates to the element of ether. Its true purpose is to speak truth and to receive the truth.

Sixth chakra, third eye (between the eyebrows): This symbol is made up of two large indigo lotus petals and a circle containing a downward-facing triangle. The triangle serves a dual purpose in its symbolism. It is representative of the channeling of information to the point or seed of the triangle, from which wisdom emerges. Viewed from the other direction, the triangle's widening sides are symbolic of expanding one's wisdom leading to enlightenment. The circle inside the triangle symbolizes the expansion of our consciousness

beyond the confines of our third dimensional self. The lotus petals are symbolic of knowledge. This chakra is associated with light, spiritual vision, and inner sound. Its true purpose is to use discernment, insight, and intuition instead of judgment.

Seventh chakra, crown (top of head): This symbol is made up of a thousand violet lotus petals. Some illustrations of the crown chakra symbol will include an Om symbol seated in the lotus. Om is symbolic of the Absolute—all that was, is, and will be. The crown chakra ties you to the Divine and Brahman, the supreme self beyond time and space—pure consciousness. This chakra is associated with cosmic energy, time/space, and pure consciousness. Its true purpose is to experience the divine meaning of life.

Chakra symbol tattoos interact directly with your energy field and your chakras. As a healing tool, they help to release energy blocks held in the chakras and create a path for the free flow of energy in each chakra center. This energy flow initiates a balancing and cleansing effect as it heals the physical, emotional, and spiritual nature associated with each of the chakras. The effect of embodying the chakra symbol tattoo is often invigorating, adding a noticeable boost to one's vitality.

Tattoo symbols according to style

There are thousands of symbols that can be inked on as a tattoo; some are trendy and others timeless. Most images have a rich history dating back to ancient times and are often incorporated into different styles of tattooing, such as American traditional/old school, traditional Japanese, tribal, geometric/dotwork, hand-poked, and memorial, just to name a few.

Symbols may take on a different meaning according to culture, color, and style. For example, the symbolism of dragon tattoos cover

a wide range of meanings. For the Japanese, dragons represent balance and wisdom. In European cultures, the dragon is considered to be an evil and dangerous creature. So, as you can see, symbols speak many languages.

There are some important things to remember before you decide your style and tattoo symbol. You want to make sure you do your own research and view a variety of different designs and styles to fully understand what your tattoo represents and what it means. Remember: you will be embodying the image, colors, and meaning of your tattoo. Following are some examples of different tattoo styles and the symbolic meaning of their tattoo art and imagery.

American Traditional/Old School

American Traditional/Old School tattoos feature bold black outlines and a limited color palette. These tattoos are done with impeccable precision, and linked to the invention of the first tattoo gun. Norman "Sailor Jerry" Collins is synonymous with old school tattoo design. Considered the father of traditional tattoo design, Sailor Jerry was a Navy man who picked up the art of tattooing during his voyages through the Polynesian Islands, where tribal tattooing was a common practice among the people of the South Pacific. Sailor Jerry settled in Hawaii, where he opened a tattoo parlor, which became a hangout for sailors. This is where Sailor Jerry's old school tattoo designs started and made their way around the world.

Typical American Traditional/Old School tattoos include:

- **Anchor:** A reminder of what keeps you steady.

- **Crossed cannons:** Symbolizes a sailor who has done military service.

- **Dagger:** Symbolizes justice, death, war, or confrontation; the dagger appears in many military tattoo, seals, and crests.

- **Eagle:** Symbolize honor, prowess, and intelligence; they were very popular during wartime because the eagle is a symbol for the United States of America.

- **Nautical star:** Symbolizes the sailor's ability to find his way home.

- **Pig and rooster tattoos on the feet:** Worn by sailors in World War II as a good luck charm to keep the sailor from drowning.

- **Pin-up girl:** Represents variations of femininity, from maidenly to sexy, usually inked in bold color.

- **Ship:** Symbolize both adventure and being homeward bound.

- **Swallow:** Symbolize a sailor's travels; these birds are also associated with the idea of return.

Traditional Japanese

Traditional Japanese tattoo art, known as *irezumi*, is created by repeatedly stabbing a brush of needles into the skin and depositing brightly colored inks. Traditional *irezumi* is usually done as a full body suit or as a "sleeve" on the arm or leg. It is cut off at the neck, wrists, and ankles so it doesn't peak out of clothes. In Japan, tattoos are frowned upon and considered to be intimidating because *irezumi* is traditionally practiced by Japanese criminals, notably members of the Yakuza.

Some traditional Japanese symbols include:

- **Demon (*oni*):** Represents a belief in the spirit world where demons carry out punishment of the unjust and evil; *oni* are generally known to be evil, but the good ones symbolize protection.

- **Dragon *(ryū)*:** Symbolizes generosity, balance, wisdom, and a strength that is used to benefit mankind.

- **Flowers (*hana*):** These have roots in traditional Japanese religion, folklore, literature, and art.

 - **Lotus *(ren)*:** Protection.

 - **Cherry blossom *(sakura)*:** A reflection of one's own mortality.

 - **Chrysanthemum *(kiku)*:** Perfection and in some cases deity, as well as happiness, joy, and longevity.

 - **Rose *(bara)*:** Balance, undying love, and new beginnings; if it's without a stem it symbolizes loss, defense, and thoughtlessness.

- **Lion-dog *(komainu)*:** Signifies protection, strength, and courage.

- **Phoenix *(fushichō)*:** Symbolizes rebirth and triumph.

- **Snake *(hebi)*:** Symbolizes wisdom and protestation from misfortune.

- **Tiger *(tora)*:** Represents courage and strength; tigers are said to control the wind and protect against bad luck, evil spirits, and disease.

- **Waves *(nami)*:** Indicate life and provision, but waves can also be dangerous.

Tribal tattoos

Tribal tattoos are recognizable from their thick, black, curved shapes and lines and large-scale designs, which are usually inked to emphasize the muscles on the body. Traditional Maori, Polynesian, and Samoan tattoo styles were used to identify wearers as members of a specific tribe and show their social status. They were also inked for medicinal and spiritual rituals. The tattoos of warriors often included animal and other nature-inspired designs that illustrated the warrior's strength and prowess in battle. Patterned tribal armband tattoos showed rank or status.

Tribal tattoos carry meanings that are relevant to certain tribes. Keep in mind that tribal tattoos are imbued with spiritual energy and are sacred to some indigenous cultures, so wearing it with respect should be observed at all times. Remember, you embody the essence and energy of tattoos, so it is important to understand the symbolism of the tribal design you have inked. Tribal tattoos in modern culture are purely aesthetic and often incorporate modern images, designs, and subject matter that, in a way, overshadows the true meaning of the tribal tattoo's heritage.

The Maori are the indigenous people of New Zealand. Their body art is known as *moko* or Maori tattooing. Aside from symbols, the Maori also use different patterns that represent courage, prosperity, health, and achievement. Maori are well-known for the full facial tattoos, and they consider tattooing to be highly sacred. Some traditional symbols are:

- **Fish hook (Maori: *hei matau*):** Represents prosperity.
- *Hei tiki:* Denotes good luck; also considered a symbol of fertility.
- **Single twist:** Resembling a number 8, it signifies the path of life and is considered the symbol of eternity.
- **Spiral/*koru*:** Symbolizes new beginnings, growth, and harmony.

Polynesians (Tongan and **Samoan)** developed tattoos into an interesting, cultivated art. Because they had no written language in their culture, they relied on tattoos full of distinctive signs to express their identity and personality.

Placement on the body plays an important role in Polynesian tattooing because it has an influence on the tattoo's meaning. The upper part of the body is related to the spiritual world and heaven, while the lower part of the body is related to the world and to the earth. Tattooed genealogy tracks on the back of the arms suggest that the back may be related to the past and the front to the future.

Tongan warriors were tattooed from the waist to the knees with a series of geometric patterns, consisting mostly of repeated triangle motifs, bands, and areas of solid black. Some traditional symbols are:

- ❧ *Enata*: Resembles a curved capital E; symbolizes men, women and sometimes gods; upside down, it represents defeated enemies.

- ❧ **Ocean waves:** Indicate ideas such as life, change, and continuity through change.

- ❧ **Shark teeth:** Look like a series of triangles with a line above; indicate protection, guidance, strength, and ferocity.

- ❧ **Spearhead:** Symbolizes the warrior nature as the spear; can represent the animal stings.

- ❧ **Turtle:** Signifies health, fertility, longevity, and peace.

Bornean Dayak tattooing is very ritualistic, and tattoos are created by artists who call in spirit guides to reveal a design. Because they believe spirits embody everything, each tattoo motif represents something spiritual and meaningful. They draw on this efficacy by tattooing floral patterns consisting of plants with curative or protective endowments and powerful animal images. Their tattoos are a

deep blue/black color made of soot or powdered charcoal. Some traditional symbols are:

- ❧ ***Entegulun*:** Symbolizes a successful head-hunting raid; participants were promptly recognized with tattoos inked on their fingers, made out of dots or chevron designs. (Head-hunting is now obsolete.)

- ❧ ***Bunga terung*:** A flower with a spiral (*tali nyawa*) in the center, said to guard from evil spirits; it is always to be done in pairs, offering protection to both sides of the person.

- ❧ ***Kala*:** Serves as protection from malevolent spirits; an abstract representation of the scorpion based on the highly stylized image of the *aso*, a mythical dog/dragon.

Hawaiians referred to the art of tattooing as *kakau*. Ancient Hawaiians would cut the skin open, then pour tattoo ink inside the cut. Traditional styles used geometric patterns and symmetric designs in black ink. Tattoos were used as a form of protection, identification, or mourning. Every one of their tattoos would be symbolic and hold deep meaning. Together, they told the person's life story, including their rank and where they had been. Some traditional symbols are:

- ❧ **Sea turtle:** Represents a long life and fertility.

- ❧ **Shark:** Symbol of protection for the wearer.

- ❧ **Shells:** Bring prosperity and wealth.

- ❧ ***Tiki*:** Symbol for the original ancestor of all humans; also known for the ability to sniff danger before it occurs.

Geometric/dotwork

Geometric/dotwork tattoos are intricate styles featuring complicated geometric images that are created with nothing but dots. This type of tattooing has a very organic look and takes on many forms within the wide scope of tattooing. It is a good method to use for tattooing sacred geometric symbols that refer to shapes and patterns found in nature. They're also considered very spiritual tattoos. Most of the time, these designs and patterns are perfectly symmetrical. Some of the more common designs using dotwork are mandalas, platonic solids, and many geometric shapes. Some traditional symbols are:

- **Flower of Life:** Symbolizes the basis of all life forms, including the human body and the energy systems. In its basic form, it is comprised of seven or more overlapping yet evenly spaced circles that, when drawn out, form a flower-like pattern with the symmetrical structure of a hexagon.

- **Gordian Knot:** Represents a tough problem or the complexity of life. Its most basic form is represented by at least three interlocking rings.

- **Mandala:** Symbolizes wholeness; there are many different styles and types of mandalas (see earlier in this chapter).

- **Metatron's Cube:** Archangel Metatron is the angel who watches over the flow of energy in a mystical cube known as Metatron's Cube. It is comprised of all of the geometric shapes in God's creation and symbolizes the patterns that make up everything. It's composed of 13 equal circles; lines from the center of each circle extend to the centers of the other 12 circles.

- **Nautilus shell:** Signifying perfection and beauty, it is a logarithmic spiral that represents the golden mean (1.6180339..., which goes on until infinity).

- **Platonic Solids:**

 - **Cube (Earth):** A three-dimensional solid object bounded by six square faces, facets, or sides, with three meeting at each vertex.

 - **Dodecahedron (Ether):** Composed of 12 regular pentagonal faces, with three meeting at each vertex; it has 20 vertices and 30 edges.

 - **Icosahedron (Water):** A regular polyhedron that has 20 faces; all faces are congruent, equilateral triangles.

 - **Octahedron (Air):** Composed of eight equilateral triangles, four of which meet at each vertex.

 - **Tetrahedron (Fire):** Also called the triangular pyramid, it contains four faces, four vertices, and six edges.

Hand-poked

Hand-poked technique goes back thousands of years. People originally used pointed bones, shark teeth, or thorns to decorate their skin with tattoos. Modern-day hand-poked tattoos are done by using a metal rod with a needle on the end. More tattoo artists are revisiting this traditional method of tattooing. There is a very natural, organic look to hand-poked tattoos. This method works well for small, simple symbols, including Celtic and Norse Runic tattoos and spiritual sigils. Runic and sigil tattoos need to be carefully considered because they are powerful charm-like tattoos that can be dangerous if created incorrectly or for the wrong reason.

Sigils are a type of symbol created for specific magical intent, bridging the gap between the conscious and subconscious mind. Sigils implant intent and program your subconscious mind to empower your sigil. Some small symbols (with big meanings) are:

- **The rune *valknut* (Death Knot):** One of Odin's symbols associated with the dead, possibly of the battle-slain. Some believe wearing or having this symbol tattooed is bad luck because it is associated with death. It is a symbol consisting of three interlocked triangles.

- **The rune *inguz*:** Two interlocked open ended triangles (one facing east and one facing west) that represent fertility and new beginnings, it's also a rune of transitions that reminds us to leave the past and matters of the past behind us.

- **Elven Star:** A seven-pointed star that represents the number 7 (days of the week, pillars of wisdom, and the Faerie tradition of Wicca).

- **Solar Cross (Odin's Cross, Sun Cross, Wheel of Taranis):** Composed of an equal-armed cross within a circle and symbolizes the solar calendar: the movements of the sun, marked by the solstices.

 - Sometimes the equinoxes are marked as well, resulting in an eight-armed wheel.

 - The swastika is also a form of solar cross; it's likely the oldest religious symbol in the world.

- **Enneagram:** A nine-pointed star composed of three overlapping triangles; it signifies the sphere of *Yesod* (the power of connection), the moon, dreams, and illusions.

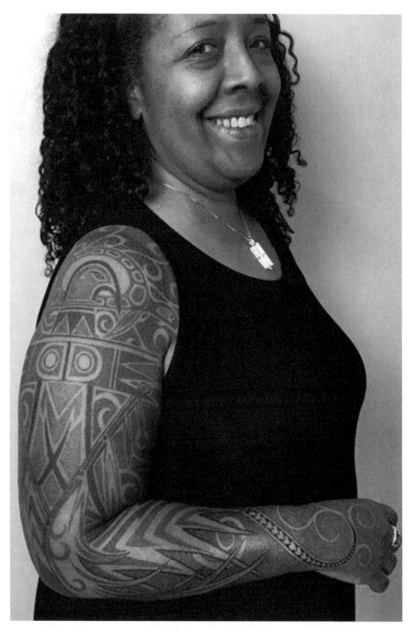

Tattoo by Daemon Rowanchilde. Photo by Raven Rowanchilde.

Memorial tattoos

Memorial tattoos are in a class of their own. These tattoos are very symbolic and hold a very special space on the body and in the consciousness. They are an emblematic tribute to a loved one who has passed on. They can be inked as a simple symbol, an elaborate portrait of the deceased, or even just the name or initials of those who have passed away. A variation of the memorial tattoo is the cremation tattoo, which is perhaps the most personal tattoo a person can get. There is a growing interest in having the ashes of a loved one sprinkled in your ink.

Allyson Richmond wanted a tattoo in memory of her late husband, Gary, and went beyond getting inked with the usual symbols of crosses, lilies, or portraiture. Instead, Allyson had Gary's ashes infused into her memorial tattoo that consists of meaningful symbols to her. Allyson shared her beautiful experience:

> The process of getting a memorial tattoo has been an opportunity for me to reflect on and confront experiences that had slipped unnoticed into my psyche and influenced my emotions. I'm beginning to fully realize some of the ways my 10 brief years with my husband, Gary, especially his illness and death, have affected me because I'm finally dealing with our past.
>
> I had always been curious about the cremation tattoo process, and after watching the moving video in the "Ashes to Ink" blog post on Daemon Rowanchilde's website, I began to seriously consider incorporating some of Gary's ashes into my memorial tattoo. I was anxious about traveling with his ashes internationally, but after speaking with customs officials in both Canada and the United States, and finding a cremation pendant that would pass inspection

without incident, I decided to travel with some of Gary's ashes.

During the most excruciating periods of the tattoo process, I focused on memories of Gary's trials to keep my own pain in perspective. And upon reflection, I think my flashbacks to those times was my unconscious way of attempting to symbolically share in the burden of his illness, even though it was after the fact.

Since I wanted Gary's ashes tattooed in the design itself, Daemon suggested that I spread some of his ashes on one area and then he'd tattoo over it. I decided on a small place on my inner wrist. After the tattoo was complete, I spread some of his ashes on the image of one of the wings of my tattoo while listening to and singing Bob Marley's "Is This Love." It was our wedding song. I felt happy as I was spreading his ashes. My tattoo of the thunderbird, turtle, owl, wings, and lotus flower vines that spiral and connect all the images together are medicine. They all seem alive. The entire process was healing.

Upon arriving home from my final trip, the full force of the tattoo and what it means hit me. I'm wearing a memorial and at the same time, I see my tattoo as powerful—like Gary.

As you can see, there is a never-ending selection of styles and symbols to choose from when you're deciding to get a tattoo. Always make it a point to really understand the deeper meaning of the images you are choosing to embody. Keep in mind that cultural differences can alter the meaning of a symbol, so it is a good idea to think

about what the symbol will mean in the context of your tattoo and the style of tattooing you choose.

Aside from the tattoo genres mentioned in this chapter, there are also many other interesting styles to choose from, such as neo-traditional, realism, watercolor, new school, abstract, gray wash, fine line, portraits, graffiti, cartoons, or anime. The list goes on.

As we move through the cycle of life, we cross many thresholds and have innumerable experiences. Sometimes your tattoo needs an update or even a removal. What do you do with your ink when your consciousness shifts?

SCARS THAT WOUND, SCARS THAT HEAL

Sometimes we make a mistake and get an *un-conscious ink*, or a tattoo for the wrong reasons. It could have been inked because it came from a place of ego, not soul. Perhaps you made a bad decision by not checking out the tattooist and the quality of their work. Maybe you were in the wrong frame of mind and captured a lot of negativity within your tattoo. Whatever the reason, a bad tattoo can wreak havoc in your life while you try to figure out how to cope with your ink disaster.

I interviewed numerous people who have regrettable ink and most admit their decision to get a tattoo was impulsive and not really contemplated. Their experiences with having a bad tattoo included suffering from severe depression and panic attacks. One person told me they believed their tattoo was attacking them because they felt the presence of an infused negative entity after getting inked. Some people even resort to therapy and antidepressants over a bad tattoo. Bad ink can mess with your psyche and consume you with thoughts on how to get rid of it.

Tattoos symbolically speak the language of your inner truth. They are visual reminders of your journey through life that mark special moments, certain mindsets, and inner visions. We all shift; no one stays the same. As we move through life, we change and update our style. You may decide to revise an older tattoo by adding to the image, or possibly want to have some regrettable ink removed because it is totally not in line with your current philosophies.

Deciding to remove a tattoo is a process because, as discussed in previous chapters, your ink goes deeper than your skin. It is also an imprint into your consciousness, where it stays in the form of an invisible scar. Having a tattoo removed can stir up some emotional energy and anxiety because tattoos in themselves are self-contained stories, symbols that represent a timeline of your life. Removing the tattoo only gets rid of the visual reminder; the story scar remains.

Many people don't realize that imprinted emotional memory can't be eliminated, but it *can* be transmuted. Everything in its most basic form is a vibration that can be modified physically, emotionally, and spiritually. The archetypal voice represented in the tattoo may no longer resonate with you. For example, if you have a tattoo that really bothers you and you opt out of total removal, you can alter the symbol. However, for it to be a successful change, deep soul work must also be performed. You have to heal on all levels, not merely the surface.

Referencing previous chapters, especially Chapters 2 and 6, can help you to discern what body placement and symbols work best for you when considering how to deal with a tattoo that has to shift in order to resonate with your body, mind, and spirit. The body physically holds the tattoo image while the attached thought-form, the structured interdimensional energy that is the archetype of your creation, spirals deep into the levels of consciousness.

The symbols and images you tattoo all have an elemental quality, such as that of fire, earth, air, water, and ether. For example, a symbol representing a fire element can be consciously added to an existing tattoo in order to symbolically show transmutation by fire. Fire is equated with birth and resurrection and represents determination, but it can also be consuming if there are no boundaries. Fire also shows passion and hatred; therefore, your intention will determine the direction it takes when symbolically added to an existing tattoo. The correct mindset, intention, and symbolic elements initiate change, whereas the opposite causes intensified problems. Tattoos can be symbolically altered and shaped by using the rubric of intention, archetypes, and the elements of all creation.

Just don't run out and get a cover-up tattoo without doing the preliminary soul work. Ask yourself what shifted in your life. Identify the emotions you feel as you ruminate through the reason for and

experience of getting your tattoo in the first place. This opens a dialogue with your higher self and allows you to cross the threshold into a more evolved mindset. Don't make changes out of anger or frustration, but rather through understanding and being present in your life.

So, how do you deal with a tattoo that turned out to be a bad ink job? Some tattoos are not good from the very beginning because the rendering of your ideas falls short of your expectations. Make sure you and your ink alchemist understand each other before the decision to commence with the tattooing ritual begins. The tattooist should work with you to determine the why, where, and how, which equates to mindset, body placement, and style. The *why* is a question to be seriously and respectfully contemplated. A screwed-up tattoo isn't like a bad haircut you can grow out. It is a physical commitment on the body, a permanent commitment in your consciousness, and shared energy between you and the tattoo artist.

Keli Vale, a Philadelphia-based jazz singer and songwriter, shared her dreadful tattoo experience:

> One day after work my friend and I went to get tattoos. I had envisioned a Celtic knot at the base of my neck that would expand my original memorial tattoo in memory of my mother. Nothing complicated, just a Celtic knot symbol that I relate to and really like. I have a small Celtic knot on the back of my ankle and I wanted another one higher up on my body. When I saw the finished tattoo, I went into an immediate depression. It looked like a big moldy pretzel. Of course, the tattooist and shop owner told me to give it a chance, but I already knew that I hated it.

Unfortunately for Keli, tattoo removal was ridiculously expensive, which made her more depressed over her bad ink job. But all hope wasn't lost, as Keli explained:

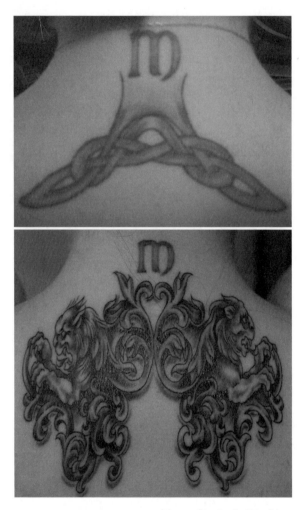

Tattoo by Carla Hopkins.

Luckily, I was able to find a medical group who would remove the tattoo if I agreed to be the guinea pig for technicians learning how to do laser tattoo removals. After numerous painful sessions, it was faded enough for me to get another tattoo over the area where the original mess was inked. On the upside, the medical group asked me to be in one of their commercials depicting tattoo removal.

Keli replaced the original Celtic knot with a beautiful tattoo of two lions intermixed with Celtic scrollwork that sit below the initial "M," the memorial tattoo in remembrance of her mother. Looking at this new tattoo, the lions are representative of fire element energy, which Keli didn't realize at the time. In a spooky consciousness sort of way, she intuitively transmuted the energy from the original undesirable ink. The lions also represent the archetype of the Creator and are so fitting to sit beneath the memorial tattoo for her mother because Keli's mother was an actress and all-around creative person.

When you build upon an existing tattoo, the images call for resonance and harmony. The inner archetypal voice of the original memorial tattoo wanted to expand with an image that represented the creative, dramatic fire rather than an elongated Celtic knot. Even though the new tattoo is beautiful, Keli said, "I still get sick just thinking about how I felt when I first saw my bad ink."

There are some tattoos that express hostile images and messages that project negative energy both inward and outward. An example is a gang-related tattoo or one that symbolizes a hate group. These tattoos are portals for adversity on your body and within your consciousness. They label you and reinforce negative energy, which accumulates and causes stress within your subtle body's energy system. Eventually, a negative tattoo can weaken your energy and lead to chronic conditions and imbalances on the physical, emotional, mental, and spiritual levels of your being. Tattoo removal is not only expensive, it can be painful, both physically and emotionally. Getting rid of a hate-related tattoo also means consciously changing your old beliefs that originally enticed you to get it in the first place.

Tattooist Dave Cutlip, owner of Southside Tattoo in Brooklyn Park, Maryland, became an overnight hero for those wishing to have racist and hate-related tattoos removed. Dave and his wife, Elizabeth, came up with the idea to do free cover-ups for people who made really bad choices by getting socially distasteful hate tattoos.

They put a post on Facebook offering free cover-ups—no questions asked—for racist or gang tattoos, which read, "Sometimes people make bad choices, and sometimes people change." Their Facebook post reached almost 1 million people.

The overwhelming response led to Dave and Elizabeth creating a crowdfunding effort for the Random Acts of Tattoo Project, which raises money to remove racist and hate tattoos. The money is directed toward tattoo artists who can't work for free and to those with training in laser tattoo removal. I spoke to Dave, and he told me he has gotten hundreds of inquiries about removing bad-choice tattoos. Dave said:

> Sometimes people make bad choices and get a tattoo that sets them up for a lot of problems. Some guy came into my shop and wanted tattoos removed from his face. He wanted to get a job and turn his life around. I couldn't help him because the tattoos were too prominent and there wasn't much I could do. After he left the shop, my wife and I wondered if we could do something to help others in the same position so we started the Random Acts of Tattoo Project. I feel really good if I can help somebody out by getting rid of their hate- or gang-related tattoo. These types of tattoos make you a target.

I asked Dave if he gets a lot of requests for cover-ups aside from the Random Acts of Tattoo Project:

> Sure, there is always somebody who decides that they want to cover up a tattoo for whatever reason. I've even changed some of my own older exiting tattoos. You know, as people change, sometimes their tattoo also has to change. I can usually find a way to alter an existing tattoo or cover up something they don't want any more so it turns into something new.

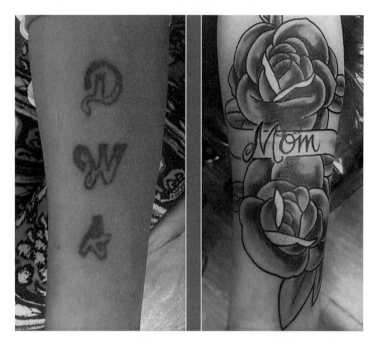

Tattoo by Dave Cutlip.

Deciding to alter an existing tattoo will also change the energy vibration that goes beyond the skin. An accompanying emotional shift takes place. Only changing what is on the outside of the body is no guarantee that old patterns of behavior won't crop up. Consciously recognizing what you feel through every layer of your being allows you to honor what was in the past and then shift into a higher energy. This, in turn, will entrain with similar frequencies and bring about better situations all the way around.

Your body area that once held a tattoo you later decided to change should be further treated with energy medicine or other holistic healing modalities that work on the quantum level. You also have to do the follow-up work for any change to be effective. Getting a tattoo removed or altered, but not doing any inner work is like hanging a picture over a hole in the wall just so you can cover up the problem. The hole has to be repaired, and even after it is fixed, there is still a patch or new piece of drywall that serves as a distant

reminder of what was once there. This is similar to how tattoo scars carry over into other incarnations. If you successfully quiet the scar's energy, however, it is less likely to be a repeated pattern in this lifetime or others.

Healing inside and out

Every scar tells a story, like the time you fell off your bike or had surgery. In a sense, tattoos are the scars that go beyond the skin to be etched as memories held within the bioenergy field. Having a tattoo removed from your skin still leaves the remaining inner scar. This scar can be a past-life memory that initially held influence over you getting a tattoo, or it can be from a new memory you downloaded into your consciousness. In either case, your decision to remove or adjust a visible tattoo signifies you have had a shift in consciousness that must be addressed on *every* level, not just the physical.

Tattoos are symbolic of the inner archetypes and emotions you invite into visible, conscious awareness. An important aspect to keep in mind when getting a tattoo, altering an existing tattoo, or removing your ink is that you can expect to feel some rolling emotions. This moving stream of emotions may trigger some past trauma held within your consciousness, even if the tattoo you are removing or altering is just a small symbol. Your consciousness retains memory of what the body experiences and vice versa. You never know what getting or removing a tattoo may stir up in your emotional memory bank.

If you have a tattoo that no longer resonates with your frequency due to a shift in your consciousness, you will feel your body telling you to alter or get rid of it. Tattoos that have a lower vibration can start to attract negative situations. Your emotions will also take a hit. Holistic practitioners who do body work can often help to move the energy getting stuck in the tattoo portal if it becomes a problem.

What types of inner healing modalities work best with tattoos? Because tattoos are part of your consciousness and not just a separate image on your skin, it is best to go with healings that are holistic and ascribe to returning you back to wholeness. Your tattoo memory will get carried over into other incarnations, so it is best to address any changes in your ink during the here and now.

Because our body stores emotional memory, deep tissue massage should be considered when either getting, altering, or removing your tattoo. Massage stimulates the mental, emotional, and spiritual bodies. During a massage, especially around a tattooed area, you may perceive all kinds of sensations from the physical to the emotional. Your deep cellular memory will be shifting and responding to the changes going on within your system. Stay present and connect with your breathing as you begin to feel the emotional release. It is not unusual for past-life memory to arise during a massage for either you or the person doing the massage.

Most forms of energy medicine, especially Reiki, are suggested healing processes for tattoos. Reiki energy goes where it is needed, whether it is for a current life situation or to relieve a past-life trauma. Reiki has a quantum effect because all lives—past, present, and even future—are all happening simultaneously. Reiki can balance the chakras, release blockages, and restore the flow of subtle energy. Body workers and people who practice energy medicine perceive where emotions are stored in the body. They can often sense perceptible vibrations of deep emotional energy captured in tattooed body areas.

Body work isn't just applicable to tattoo removals or alterations; it should also be considered a type of maintenance for your sacred body space that holds your mystic ink. Your tattoo portal receives as well as emits a very precise vibrational energy at all times. Remember: you are embodying some very sentient art imbued with ritual, intent, and emotions.

There are energy workers and healers who have had some unique experiences while working on someone with a tattoo. Mary P. O'Donnell is one of them. Mary is a licensed massage therapist and Reiki master who follows the shamanic path. She told me of one such experience she had while working on a client with an absolutely mesmerizing tattoo.

Mary first explained that when working on a client, a healer goes in with discernment and no judgment; they just go with what they intuitively feel the client needs in order to release any blockages held in the client's physical and subtle bodies. Mary told me about the time she was working on a client with a beautiful tattoo of a tree. The vibration from this tattoo was so strong she could feel herself magnetized into the image of the tree. Mary said, "It was like a multidimensional experience." She had started the session with a half hour of Reiki so she could better connect to the client's energy, then proceeded to start the massage. The massage possibly shifted some intense energy, and Mary found herself having the experience of what she called a mini shamanic journey.

This tattoo had such an extraordinary energy, almost like a portal (which we know it is). Even though she was trying to remain present so she could work on the client's muscles during the massage, Mary couldn't resist the effects of this tattoo. There was a feeling of going on a journey, to a time and place of the Druids. I asked Mary if she was tripped into something held in her own consciousness, or the client's:

> Probably a little bit of both. Trees have always been meaningful to me. In shamanism, the roots signify the Lower Worlds, the trunk is the Middle World, and the branches reach up to the Upper Worlds. These three realms of consciousness are realized in everyday language as being the subconscious,

consciousness, and super consciousness. The alle-
gorical reference is that a tree serves as a reminder
that we exist in all three worlds at the same time.
Everything we know, everything we experience, and
everything we want to know is available to us.

At the end of the session, Mary didn't mention to the client what
she had experienced. Mary said that it was (and still is) difficult to
articulate the feeling she tapped into from the tattoo, like trying to
explain a dream. It's possible that when giving a healing, she also
received a healing. Mary's experience with her client's tattoo incor-
porated massage, Reiki, and even a little bit of soul journeying that
brought about a vibrational resonance. The energies entrained and
one got pulled into the other.

The scars of healing

Scars are indicative of both wounding and healing. Ancient tat-
too practices were not only used for decorative purposes, but also
for therapeutic and medicinal purposes. It is theorized tattoo sym-
bols on ancient Egyptian female mummies were indicative of pro-
tection during childbirth. A 1,000-year-old female mummy found in
Peru had neck tattoos that contained what is believed to be healing
plant extracts. Indigenous people from the Arctic North tattooed
specific joints because they believed they were the points where evil
spirits enter the body and cause illness. Therefore, tattooing the
joints served as preventive medicine. It was common medical prac-
tice for medicine men of the Chippewa, also known as Ojibwe or
Anishinabe, to administer a healing poultice in conjunction with
tattooing as a means for the medicine to enter into the bloodstream.
The pain experienced during the treatment was the soreness leaving
the body.

Probably the one of the most famous and oldest forms of proof of what is believed to be medical, therapeutic tattooing was found on a frozen individual popularly known as "The Iceman" (Ötzi). He had been deep frozen for about 5,300 years and still retained tattoos with four groups of simple blue/gray tattoos on his spine, calves, and ankles. The tattoos were very organic, usually made up of lines or a cross. He appears to have been tattooed on or near his joints (ankle, knees, and spine) where he may have had signs of arthritis.

Today, modern medicine uses tattoos as a form of medical alert insignias in place of a bracelet or tag that may be easily lost. There has been research in using tattoos to deliver medicine, and tattoos are commonly used in cosmetic procedures to give pigment back to areas of the body that have been disfigured. There is always a corresponding inner aspect to your consciousness that follows the scars of your ink. Always remember, the body, mind, and spirit are one unit that fan out dimensionally from spirit to physical form.

Transpersonal tattooist Daemon Rowanchilde shared a beautiful story about his client Anita, whom he tattooed after her double mastectomy. Sadly, Anita passed away on March 9, 2011, at the age of 44, but Daemon's abilities as an artist, tattooist, and gifted healer helped Anita reclaim her body and sense of self before she left the physical realm.

"The hidden gift in diseases like breast cancer is that it can open deeper levels of consciousness in the person who is sick," Daemon said. "Over the course of her long illness, Anita Wintels developed the ability to communicate with angels and the spirits of departed souls. Even though her cancer was terminal, Anita wanted me to tattoo angel wings over the scars of her double mastectomy to represent the divine connection that became a huge part of her life."

Daemon continued:

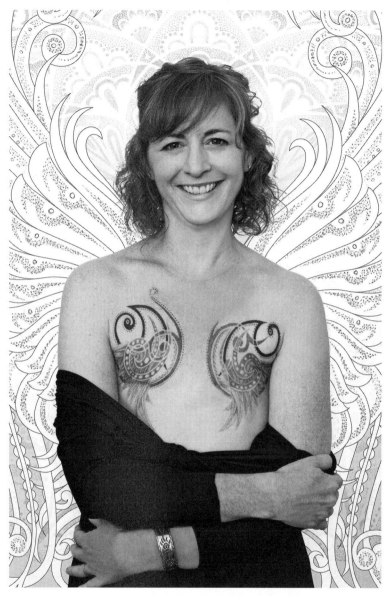

Tattoo by Daemon Rowanchilde. Photo by Ivan Otis.

Spiritual reality becomes more prominent in a person's consciousness when they face their own death or that of a loved one. However, in the case of breast cancer where the outcome is a double mastectomy, another kind of death occurs. The resultant scars can become an emotional dead zone. A tattoo, however, can not only transform a scar into art; the actual experience can create a tremendous positive shift in perception and meaning."

Daemon shared what Anita had written him after he worked with her:

You can imagine, though, that as a woman, once breasts are gone and you have this 'blank,' everything kind of shifts. All of sudden how I thought about myself sensually and intimately changed. Nobody (including myself) touched me there anymore until you started working on me...and the first wave of emotion hit me! Well now that these beautiful designs are here, that has changed. I can't even write this without tears streaming down my face.

Shortly before Anita died, Daemon had asked fashion photographer Ivan Otis to take Anita's portrait so he could incorporate it into a painting "that would not only capture the metaphysical energy of her tattoos, but also her sensual beauty, openness, and strength." Daemon said, "This image of Anita in the heart was inspired by a very meaningful dream that she shared with me (that's another story). Anita, you are in my heart, always! Blessed be."

The sacred, spiritual, and mystical elements of your tattoos hold the power of wholeness. Your inked-on images and symbols reveal the many journeys of your soul and chronicle your immortal existence. They are the scars of healing, self-revelation, memories, and

stories that reflect all of your lifetimes. The never-ending theme of life, death, and rebirth are reflected in your tattoos from the simplest of symbols to the most elaborate designs.

May you find enlightenment in your ink and aspire to consciously tattoo.

BIBLIOGRAPHY

Andrews, Synthia. *The Path of Energy: Awaken Your Personal Power and Expand Your Consciousness.* Pompton Plains, N.J.: New Page, 2012.

Argüelles, José, and Miriam Argüelles. *Mandala.* Boston: Shambhala, 1995.

Barretta, Lisa. *The Book of Transformation: Open Yourself to Psychic Evolution, the Rebirth of the World, and the Empowering Shift Pioneered by the Indigos.* Pompton Plains, N.J.: New Page, 2012.

Bruce-Mitford, Miranda, and Chuck Wills. *Signs & Symbols.* New York: DK Publishing, 2008.

DeMello, Margo. *Inked: Tattoos and Body Art Around The World.* Santa Barbara, Calif.: ABA-CLIO, 2014.

Gilbert, Stephen G., Cheralea Gilbert, and Kazuo Oguri. *The Tattoo History Source Book.* New York: Juno, 2000.

Jung, C. G. *The Archetypes and the Collective Unconscious.* London: Routledge, 2014.

Jung, C. G., and Marie-Luise Von Franz. *Man and His Symbols.* Garden City, N.Y.: Doubleday, 1964.

Lipton, Bruce H. *The Biology of Belief: Unleashing The Power of Consciousness, Matter & Miracles*. Carlsbad, Calif.: Hay House, Inc., 2015.

Mercury, Maureen, and Steve Haworth. *Pagan Fleshworks: The Alchemy of Body Modification*. Rochester, Vt.: Park Street Press, 2000.

Pratt, Christina. *An Encyclopedia of Shamanism*. New York: Rosen Pub. Group, 2007.

Rush, John A. *Spiritual Tattoo: A Cultural History of Tattooing, Piercing, Scarification, Branding, and Implants*. Berkeley, Calif.: Frog, 2005.

Villoldo, Alberto. *Mending The Past and Healing The Future With Soul Retrieval*. Carlsbad, Calif.: Hay House, 2005.

Wauters, Ambika. *Chakras and Their Archetypes: Uniting Energy Awareness and Spiritual Growth*. Freedom, Calif.: The Crossing Press, 1999.

INDEX

A

abdomen, 42

acorn, 166

Air Dragon, 140

air symbols, 139-141

American Traditional tattoo style, 179-180

anchor, 137, 179

ankh, 143

ankles, 43

anthem, 137

antlers, 165

apple, 143, 166

aqua, 141, 174

Aquarius, 140, 174

Archangel Gabriel, 141

Archangel Michael, 135

Archangel Raphael, 139

Archangel Uriel, 138

archetypes and inner journeying, 100-104, 108-109

Aries, 135, 168-169

armpits, 41

arms, 41

arrow, 165

astral body, 21-22

astrology, 167-175
wheel, 167-168

B

back, 42

bat, 140

bear, 138, 156

bee, 135

Beltane, 164-165

black, 46, 100, 111, 138, 144, 155,
 156, 173
 cat, 163

blue, 38, 45, 46, 112, 145, 177,
 183, 206
 light, 140

body frequency, 68-74

Bornean Dayak tattoos, 183-184

Brigit's Cross, 164

brow, 41

brown, 46, 138, 171

buffalo, 156

bull, 138, 169

bunga terung, 184

butterfly, 140, 156

buttocks, 43

C

cactus, 141

Cancer, 141, 170

Capricorn, 138, 173

Caregiver, 112, 170

cat, 138
 black, 163

causal body, 22

celestial body, 22

Celtic
 cross, 159-160
 rose, 135
 spiral, 158
 symbols, 156-160
 Tree of Life, 158-159

chakras, 20-22, 44, 47-53, 63, 69-
 70, 79, 92, 130, 133, 151-152
 175-178
 crown, 51, 178
 foot, 51-52
 hand, 52
 heart, 50, 177
 root, 49, 116, 176
 sacral, 49, 176
 solar plexus, 31, 49-50, 70,
 176-177
 third eye, 50-51, 177-178
 throat, 50, 177

chameleon, 144

cherry blossom, 181

chest, 41

chi, 31, 38, 52

chili pepper, 135

chrysanthemum, 181

circle, 142, 144, 148, 150-155, 157-162

cloud, 144

color, 44-47

compass, 144

cover-up tattoos, 189-202

coyote, 156

crab, 142, 170

Creator, 116-117, 171

Critic, 117-118

cross, 144

crossed cannons, 179

crown, 142

cube, 186

Cynic, 113

D

dagger, 180

demon, Japanese, 181

Devil, 135

dodecahedron, 186

dog, 138

dolphin, 142

double helix, 144

dove, 140

dragon, 115, 135, 138, 140, 143, 164, 178-179, 181, 184

dragonfly, 140

dreamcatcher, 152-153

E

eagle, 140, 156, 180

ears, 41

Earth Dragon, 138

earth symbols, 137-139

East, 155

elephant, 138

elf, 138, 163

Elven Star, 187

emotional body, 21

enata, 183

enneagram, 187

entegulun, 184

ether symbols, 143-145

etheric body, 21, 37, 48, 70

Everyman, 112-113, 173

Evil Sorcerer/Wicked Witch, 119-120

Explorer, 114-115, 173

Eye of Horus, 135

F

face, 41

fairy, 141, 165

feet, 43

fingers, 42

Fire Dragon, 134

fire symbols, 135-137

fish hook, 182

fish, 174

flames, 135

Flower of Life, 185

flowers, 181

forearm, 41

forehead, 41

fox, 138

frog, 142

full moon, 142, 162, 166

G

Ganesh, 144

gargoyle, 138

Gemini, 140, 169-170

genitals, 43

geometric tattoos, 185-186

goat, 173

Gordian Knot, 185

Green Man, 164

green, 25, 45, 46, 112, 117, 169, 177

H

half moon, 142

hand-poked tattoos, 67, 186-187

hands, 41, 42

hawk, 140

heart, 40, 111, 112, 116, 140, 156, 163

hei tiki, 182

Hero, 111-112, 169

hips, 43

horse, 138

hummingbird, 140

I

icosahedron, 186

Imbolc, 164

indigo, 142, 172

indigo, 45, 46, 142, 172, 177

infinity symbol, 30, 144

inguz, 187

inner thigh, 43

Innocent, 110-111, 174

Insatiable, 115-116

Insolent, 111-112

Introvert, 114-115

inverted triangle, 138, 142

Isis, 163

ivy, 138, 166

J

Japanese
 demon, 181
 tattoos, 180-181

Jester, 118-119, 170

Jungian archetypes, 110-120
 Caregiver, 112, 170
 Creator, 116-117, 171
 Everyman, 112-113, 173
 Explorer, 114-115, 173

Hero, 111-112, 169
Innocent, 110-111, 174
Jester, 118-119, 170
Lover, 115-116, 172
Magician, 119-120, 169
Outlaw, 113-114, 174
Ruler, 119, 172
Sage, 117-118, 171

Jupiter, 173

K

kala, 184

ketheric template, 22

knees, 43

koi fish, 142

L

ladybug, 135

Lammas, 165-166

Leo, 136, 170-171

leprechaun, 139

Libra, 140, 171-172

light blue, 140, 172

lightning, 136

lion, 136, 171

lion-dog, 181

Litha, 165

lizard, 136

lotus, 144-145, 176-178 181

Lover, 115-116, 172

lower leg, 43

M

Mabon, 166

magic in tattoos, 85-87

Magician, 119-120, 169

mandalas, 148-149, 185
 Wiccan, 160-166

Manipulator, 119

Maori tattoos, 182-183

Mars, 169

medicine wheel, 152, 154-156

meditation, 26, 69, 161, 166

memorial tattoos, 189-191

mental body, 21

Mercury, 170, 171

mermaid, 142

Metatron's Cube, 185

moon, 88, 120, 142, 152, 159-
 162, 166, 170, 176, 187

mouse, 156

N

nautical star, 180

nautilus shell, 186

neck, 41

Neptune, 174

North, 155

number 8, 139

number 11, 136

number 1 , 145

number 3, 140

number 22, 143

O

octahedron, 186

octopus, 143

Odin's Cross, 187

Old School tattoo style, 179-180

Om symbol, 145

orange, 136, 171

orange, 45, 46, 118, 136, 171, 176

Ostara, 164

Ouroboros, 164

Outlaw, 113-114, 174

owl, 140

P

panther, 139

parrot, 140

Peacemaker, 114

peacock, 140

Pegasus, 140

pentacle, 161, 166

pentagram, 160-161

Perfectionist, 116-117

phoenix, 136, 181

pig and rooster, 180

pink, 45, 46, 99, 145

pin-up girl, 180

Pisces, 143, 174

placement of tattoos, 19, 21-22, 38, 41-44, 47, 52, 69, 88, 98, 117, 130-131, 149, 176, 183

planets, 145

platonic solids, 186

Pluto, 172

portals, 11-12, 14-15, 21, 23-24, 28, 48, 50-51, 58, 61-62, 70, 72, 79-81, 84-85, 87-89, 91-95, 133, 146, 149, 175

Pragmatist, 118-119

praying mantis, 136

purple, 145, 173

purple, 25, 45, 46, 145, 173

R

ram, 136, 169

raven, 141

red, 136, 169
 rose, 136

red, 38, 45, 46, 70, 111, 176

Reiki, 24, 28, 52, 58, 63, 69, 94, 203-205

religious teachings against tattoos, 22-23

rooster, 136
 and pig, 180

rose, 165, 181
 red, 136

Ruler, 119, 172

runes, 120, 187

S

sacred geometry, 14, 145

Sage, 117-118, 171

Sagittarius, 136, 172-173

salamander, 137, 165

Samhain, 163-164

Samoan tattoos, 183

Saturn, 173

scales, 172

scarab, 143

Scorpio, 143, 172

scorpion, 172

sea turtle, 184

seagull, 143

shadow archetypes, 105-107
 Critic, 117-118
 Cynic, 113
 Evil Sorcerer/Wicked Witch,
 119-120
 Insatiable, 115-116
 Insolent, 111-112
 Introvert, 114-115
 Manipulator, 119
 Peacemaker, 114
 Perfectionist, 116-117
 Pragmatist, 118-119
 Weakling, 110-111
 Wounded Healer, 112

shamanism, 28, 58, 62, 65, 71,
 79, 118, 133, 157, 204

shark, 137, 184
 teeth, 183

shells, 184

ship, 180

shoulders, 41

sigils, 86, 118, 186-187

single twist, 183

six-pointed star, 145

skull, 163

snake, 137, 181

Solar Cross, 187

Solomon's Seal, 166

South, 155

spider, 145, 163

spiral, 145, 182

stag, 165

star, 137, 150, 160, 177, 187

subtle body/bodies, 13, 20-24,
 28, 31-32, 39-44, 48, 52-53,
 59, 69-70, 80-81, 87, 91-95,
 101, 146, 150-151, 175, 199,
 203-204

subtle energy, *see* subtle body

Sun Wheel, 164

sun, 137, 165, 171

sunflower, 137, 166

swallow, 180

sword, 137, 165

sylph, 141

T

talismans, 13, 19, 24, 26, 87-90

tattoo
 aftercare, 32-33
 cover-ups, 189-202
 medicine, 63-67

tattoo artist, choosing a, 27-30

tattoo parlor, choosing a, 30-33

tattoos as a healing experience, 202-209

Taurus, 139, 169

tetrahedron, 186

thigh, 43

throat, 41

thunderbird, 143

tiger, 137, 181

tiki, 184

tinity knot, 158

toes, 43

Tongan tattoos, 183

torso, 41

Tree of Life, 139
 Celtic, 158-159

tribal tattoos, 182-184

trident, 143

Triple Goddess symbol, 161-162, 164

Triple Moon symbol, 161-162

triple spiral, 158

turquoise, 174

turtle, 139, 183

twins, 169

U

unicorn, 145

upper arm, 41

upward triangle, 137, 141

Uranus, 174

V

valknut, 187

Venus, 169, 172

vines, 138, 166

violet (color), 45, 46, 178, *see also* purple

violet (plant), 164

virgin, 171

Virgo, 139, 171

volcano, 137

W

wand, 141

waning
 crescent moon, 142
 moon, 162

water bearer, 174

Water Dragon, 143

water symbols, 141-143

waves, 182, 183

waxing
 crescent moon, 142
 moon, 162

Weakling, 110-111

West, 155

whale, 143

Wheel of the Year, 162-163

white, 145, 170
 flowers, 164
 lily, 139

white, 46, 111, 141, 145, 155, 156, 170, 176
 flowers, 164
 lily, 139
 tattoos, 46,

Wiccan mandalas, 160-166

wing, 141

wolf, 139, 156

Wounded Healer, 112

wrist, 42

Y

yantra, 149-152

yellow, 141, 170

yellow, 45, 46, 114, 117, 141, 155, 156, 170, 176

Yule, 163

ABOUT THE AUTHOR

Lisa Barretta is the author of *Conscious Ink: The Hidden Meaning of Tattoos: Mystical, Magical, and Transformative Art You Dare to Wear*; *The Book of Transformation: Open Yourself to Psychic Evolution, the Rebirth of the World and the Empowering Shift Pioneered by the Indigos*; and *The Street Smart Psychic's Guide to Getting a Good Reading*.

Lisa is also a certified Reiki practitioner, crystal energy worker, and professional astrologer/intuitive tarot counselor. Additionally, Lisa is the executive producer for the documentary *Surviving Death: A Paranormal Debate*, which features world famous parapsychologist Lloyd Auerbach, quantum physicist Nathan Harshman, Ph.D., psychic medium Michael Tottey, and the UK's television ghost hunting personality Richard Felix.

Lisa resides in Philadelphia, and actively takes part in Reiki share groups, paranormal investigations, and most any out-of-this-world-type of events. She is a member of the NCGR (National Council for Geocosmic Research), AFA (American Federation of Astrologers), and ISIR (International Society for Astrological Research). Her passions include researching the field of consciousness along with writing, painting, and delving into ancient astrology and Wicca.